THE MAGIC OF
BLACK-AND-WHITE

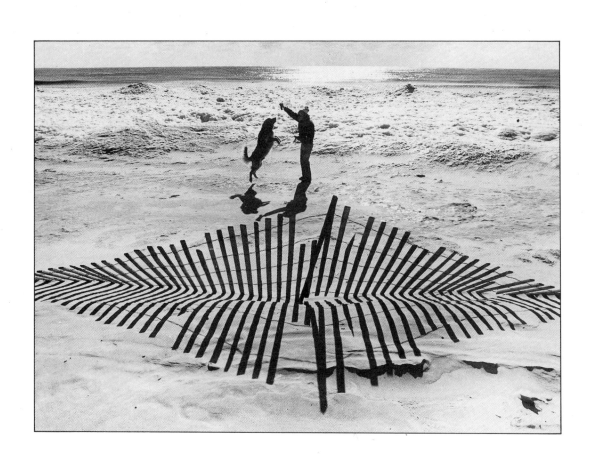

THE MAGIC OF
BLACK-AND-WHITE

Published by Time-Life Books in association with Kodak

THE MAGIC OF BLACK-AND-WHITE

Created and designed by Mitchell Beazley International
in association with Kodak and TIME-LIFE BOOKS

Editor-in-Chief
Jack Tresidder

Series Editor
Robert Saxton

Art Editor
Mike Brown

Editors
John Farndon
Carolyn Ryden

Designers
Ruth Prentice
Eljay Crompton

Picture Researchers
Veneta Bullen
Jackum Brown

Editorial Assistant
Margaret Little

Production
Peter Phillips
Androulla Pavlou

Historical Consultant
Brian Coe, Curator of the Kodak Museum

Written for Kodak by Richard Platt

Coordinating Editors for Kodak
Paul Mulroney
Ken Oberg
Jackie Salitan

Consulting Editor for Time-Life Books
Thomas Dickey

Published in the United States
and Canada by TIME-LIFE BOOKS

President
Reginald K. Brack Jr.

Editor
George Constable

The KODAK Library of Creative Photography
© Kodak Limited. All rights reserved

The Magic of Black-And-White
© Kodak Limited, Mitchell Beazley Publishers,
Salvat Editores, S.A., 1985

Library of Congress catalog card number
ISBN 0-86706-351-3
LSB 73 20L 16
ISBN 0-86706-350-5 (Retail)

Contents

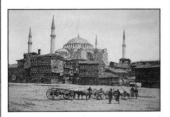

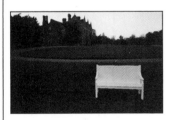
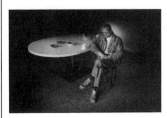

THE WORLD IN BLACK-AND-WHITE

The world around us is filled with rich and subtle colors that are a pleasure to the eye. Modern color films can record these hues with stunning immediacy. Why then should photographers bother to take pictures that record everything in shades of gray?

There are many answers to this question. Sometimes the reason is a practical one: many professional photojournalists use black-and-white film simply because the newspapers they work for run only pictures printed in black ink on white paper. But for photographers who have the luxury of choice, the motives are more subtle. Some prefer black-and-white because it offers more control over the final image: they can print one negative in a thousand different ways. Others believe that color can make a picture look brash and gaudy, or can distract from the urgency of social comment that a photograph can convey. Still others, such as the photographer who took the picture at right, love the purity of black-and-white, the way it reveals shapes, lines and tones that color can obscure.

Despite this variety of motives, there is one underlying response that all black-and-white photographers share – an enjoyment of the sheer beauty of rich black and gray tones on white printing paper. The portfolio of pictures on the following nine pages celebrates this beauty and indicates the variety of imaginative approaches that black-and-white film can encompass.

Pedestrians walk across a suspension footbridge that seems to span a chasm of inky black space. The photographer exposed for the highlights and printed on high-contrast paper to create a powerfully graphic image.

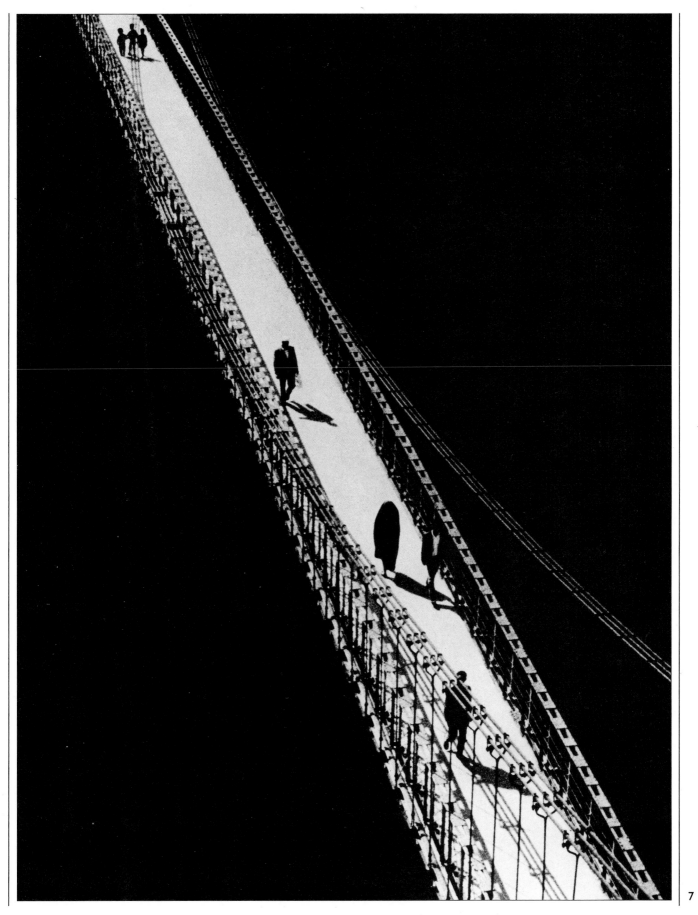

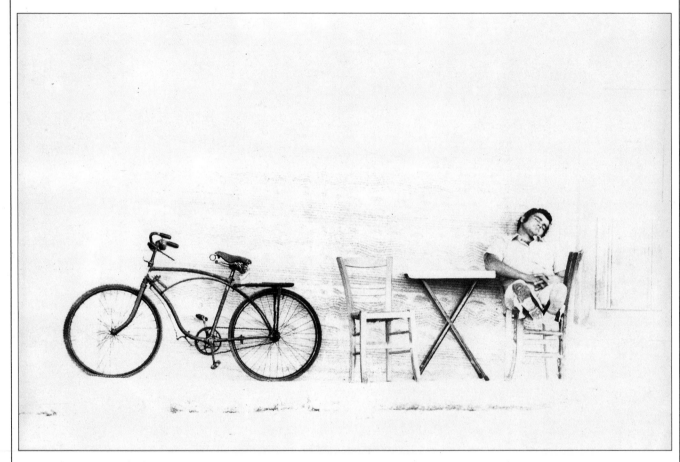

A sidewalk scene outside a café seems
to have been sketched in thin air. To
achieve this effect, the photographer
deliberately underexposed during
enlargement in the darkroom. A choice
of hard printing paper produced a contrasty
image dominated by the strong, dark shape
of the bicycle.

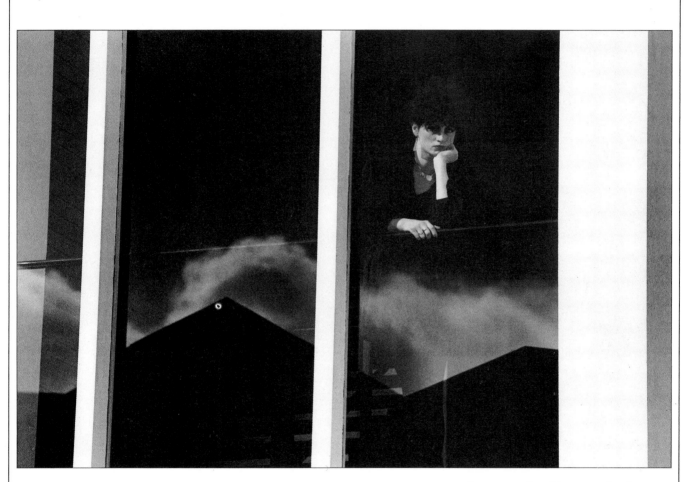

A woman, her chin propped on her hand, gazes out through a large window that catches the reflection of the sky and a pair of gabled roofs. Reflections are often difficult to interpret in black-and-white photographs: here, the photographer exploited a confusion of planes to create a mysterious image.

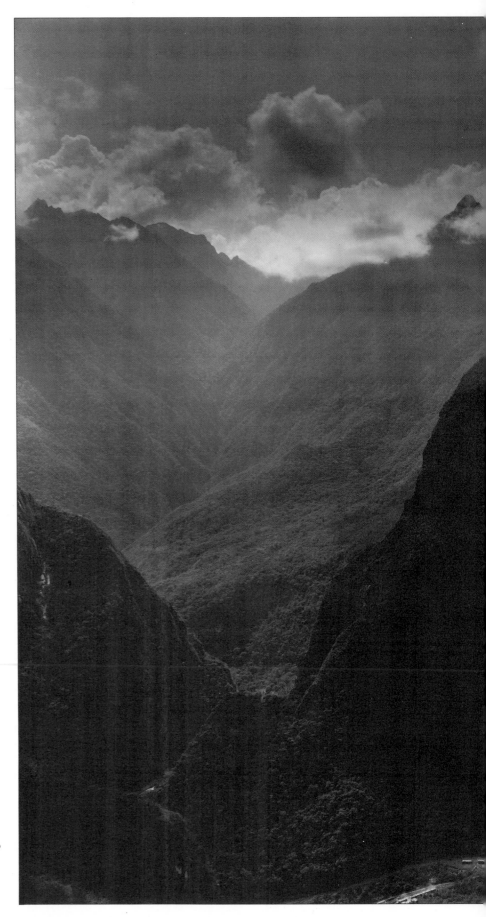

Rain clouds *graze tree-mantled peaks in the Peruvian Andes in a view from a high mountain road. The photographer used 4 x 5-inch sheet film to capture the scene's subtle gradations of tone and the areas of fine detail, such as the rocks and vegetation flanking the stream at bottom right.*

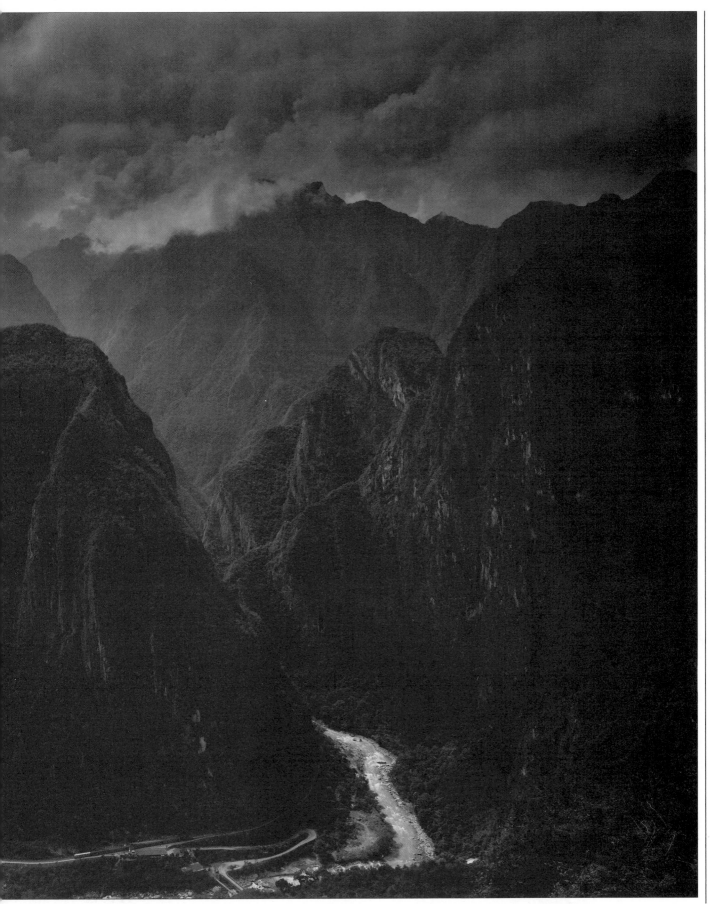

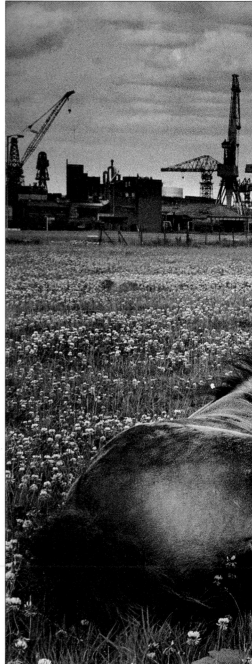

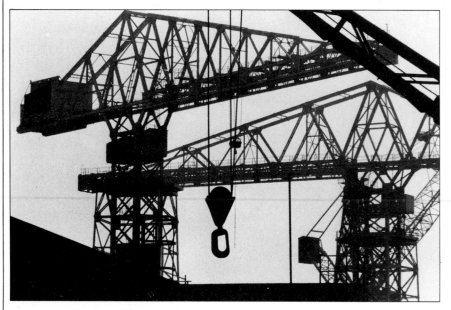

Dockyard gantries crisscross a hazy
sky. One approach would have been to
underexpose the scene, and print on a hard
paper to create a black silhouette.
However, the photographer wanted to
maintain some depth, so he gave enough
exposure to separate the foreground
from the lighter cranes behind,
then printed on medium paper.

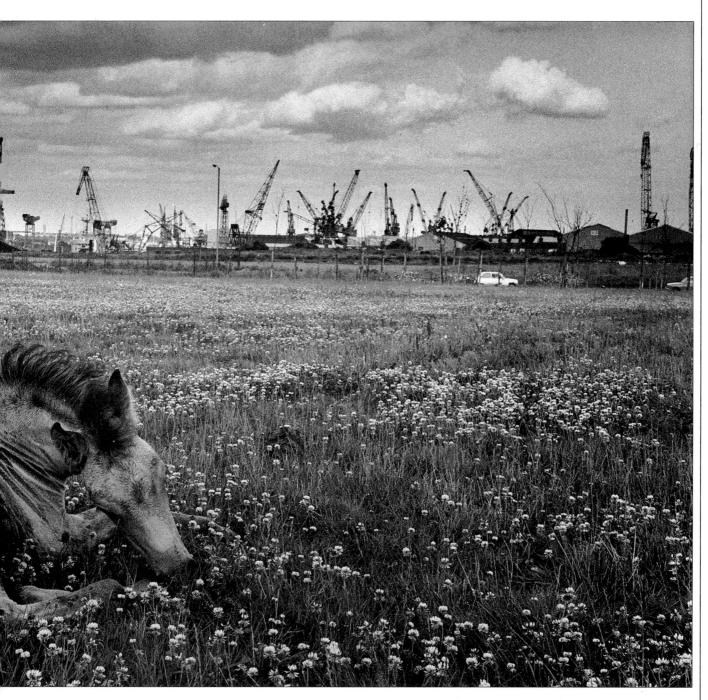

A horse lying down in a clover field near a loading dock twists back its head in a contorted pose. This view is part of a photo-essay on daily life in the industrial belt of northeastern England. Medium-speed ISO 125 film captured a wealth of detail, yet gave the photographer a wide choice of shutter speeds in the subsiding afternoon light.

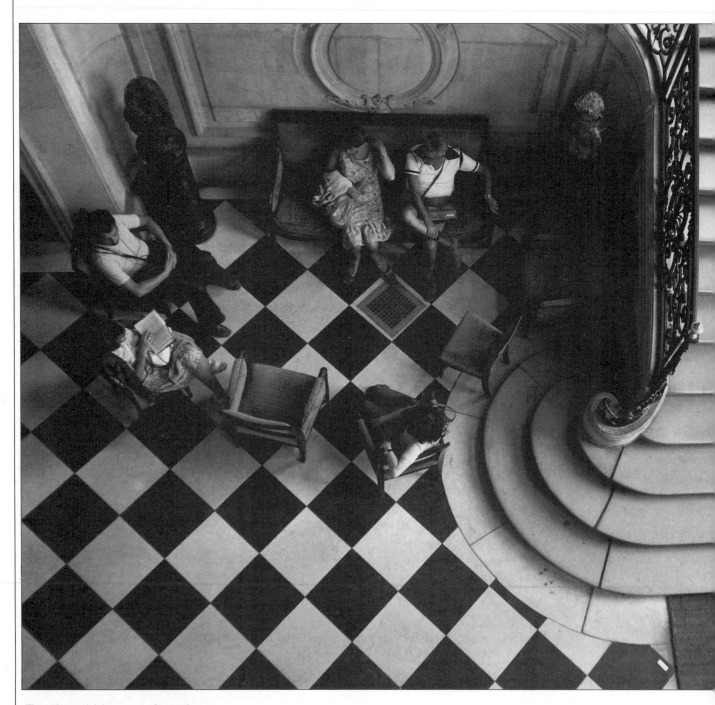

Tourists visiting a grand mansion pause
for a rest at the foot of a staircase, as the
photographer observes them from a
landing above. In color, the strip of carpet
and the visitors' variously colored clothes
would have lessened the compositional
unity of the image. Black-and-white,
however, adds impact and provides a
unifying coolness of mood.

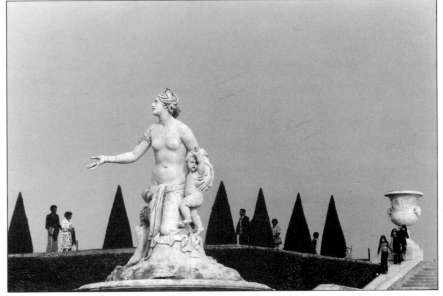

An ornate statue, an urn and a
row of conically trimmed trees suggest
a formal garden in a view by the same
photographer, taken for the same photo-
essay. Black-and-white film enabled him
to emphasize the contrast of flowing and
geometrical shapes, thus revealing the
continuity of design between the garden
and the interior.

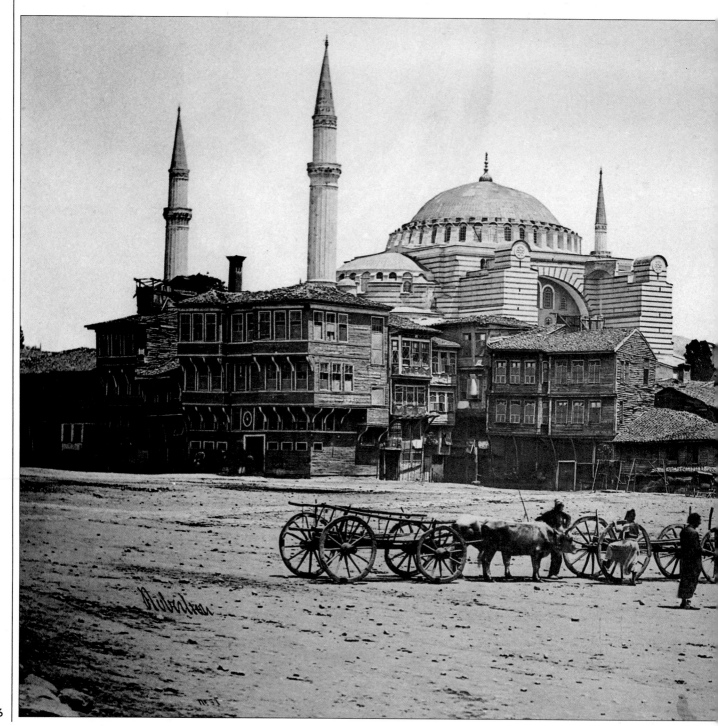

THE BIRTH OF BLACK-AND-WHITE

The earliest photographers were pioneers in a real sense. Lacking the convenience that we take for granted today, they broke new ground through tireless determination and immense resourcefulness. Most of them constructed their own cameras, made their own light-sensitive materials and mixed their own processing solutions from raw chemicals. Just making a visible image was often an achievement, and fixing the image so that it could be viewed in daylight must have seemed at times like trying to catch the wind.

Despite these initial difficulties, photographers of the late 19th and early 20th Centuries produced pictures of extraordinarily high quality. Some of these historic pictures, such as the one at left, are technically so impressive that they look almost contemporary, although the subject matter comes unmistakably from the past. This impression of modernity is especially apparent with images that are reproduced in black-and-white instead of the various shades of russet, sepia, yellow and blue that were more usual in the earliest prints.

After the first successful experiments, photographic images soon began to alter human experience in both the public and the private sphere. Photography not only gave a new dimension to portraiture but also expanded man's horizons by providing immediate visual records of other people's lives and landscapes. The following section traces the exciting technical developments that lay behind these transformations, from the very first monochrome photographs to the advent of the snapshot.

The dome and minarets
of Santa Sophia, Constantinople
(now Istanbul), rise above
surrounding buildings in a print
signed by the photographer
James Robertson, who made it
from a collodion wet-plate
negative he took in the 1850s.

The first photograph

One sunny morning in the summer of 1826, a French inventor named Joseph Nicéphore Niepce placed a small wooden box on the window ledge of his workroom. In a hole at the front of the box he had fixed a lens, and inside the box he had put a pewter plate coated with a type of bitumen. He left this crude camera in place for eight hours, then removed the plate and washed it with oil of lavender. Where light had struck the plate, the bitumen had hardened; in the unexposed areas it was dissolved by the oil, revealing the shiny metal beneath.

The result was the first stable photographic image, which is reproduced unretouched below. Niepce had been trying to capture the same image

Joseph Nicéphore Niepce's country estate at Châlon-sur-Sâone, France, was the site of the first photograph. The circled area shows the window of Niepce's attic workroom, which provided the viewpoint for the picture. Niepce's success followed 10 years of experiments.

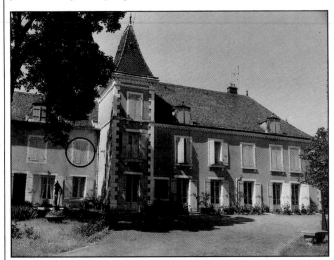

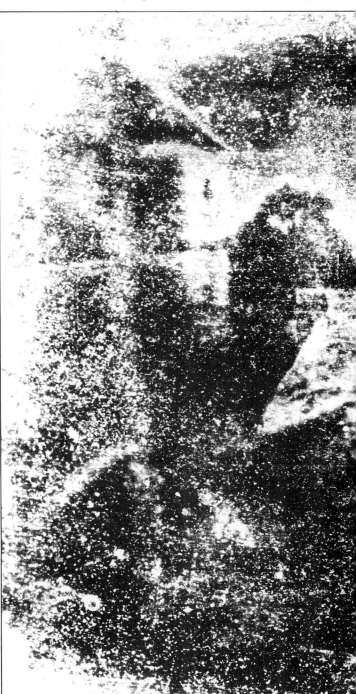

since 1816, always taking an identical viewpoint from the attic window at his country house. The letters he wrote to his brother Claude describing this particular view of a courtyard and his attempts to photograph it make it possible for us to identify elements in the picture. Although Niepce was the first to fix a camera image, his process was of little practical use, since it required such lengthy exposures. However, in 1829 he formed a partnership with Louis Daguerre, and the work that the two men did together contributed to Daguerre's invention of the first practical photographic process. Sadly, Niepce, who died in 1833, never saw the eventual fruits of his pioneering work.

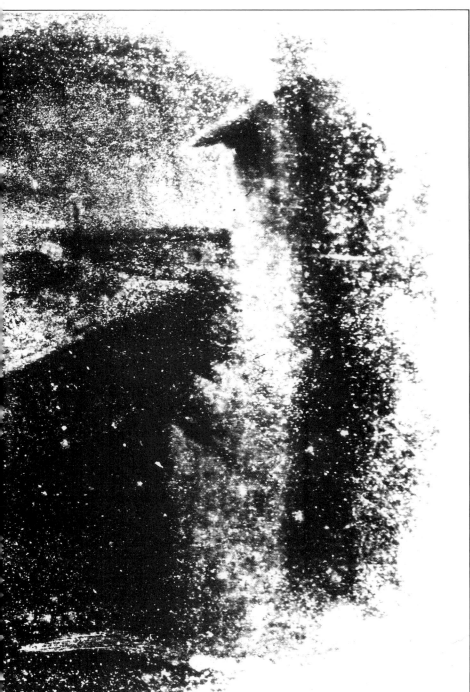

The first photographic image
The elements in Niepce's image are scarcely recognizable because the poor light-sensitivity of the materials demanded long exposure. The diagram provides a key. The tower on the left is a pigeon loft. On the right, a patch of sky shows through the branches of a tree. In the center is the sloping roof of a barn, and in the background are the long roof and chimney of the estate's bakehouse. During the eight-hour exposure, the sun moved from one side of the courtyard to the other, so that shadows fall in two directions.

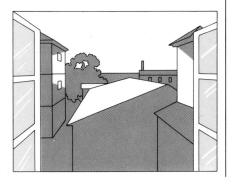

Mirror pictures

In January 1839 the French Academy of Sciences in Paris was informed that the painter and stage designer Louis Daguerre had discovered a way of making pictures by the action of light on a silver plate. Daguerre was fully aware of the importance of his "daguerreotype" process. "I have seized the fleeting light and imprisoned it," he proclaimed. "I have forced the sun to paint pictures for me." The Academy shared his exhilaration, and Daguerre was persuaded to turn his process over to the public domain in return for a pension from the French government. In England he obtained a patent.

Daguerreotypes had microscopically fine detail, but it was impossible to view the image in the way we view paper prints today, as the comparison opposite demonstrates. To see the picture in its correct tones it was necessary to reflect something black in the shiny surface of the plate. However, this small inconvenience did not deter a picture-hungry public. The medium blossomed, helped by various improvements – for example, a lens manufactured in Germany that created an image 20 times brighter than the images produced by Daguerre. The tones of daguerreotypes were enriched by gilding. And by 1841 the exposure time had been reduced from many minutes to around 25 seconds on a sunny day. This made portraiture feasible, and by 1853 there were more than 80 studios in New York City alone.

Making a daguerreotype
The first step in Daguerre's process was to polish a silver-coated copper sheet to a brilliant shine. A sensitizing box (1, right) made the plate light-sensitive by fuming it in iodine vapor. Exposure in the camera (2) reduced the silver iodide to silver in proportion to the intensity of the light from the subject. The latent image was then made visible by treatment with mercury vapor in a processing box (3). Finally, a hot salt solution fixed the image by making the plate insensitive to light.

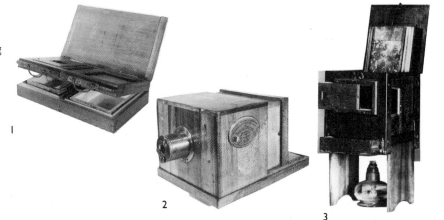

1

2

3

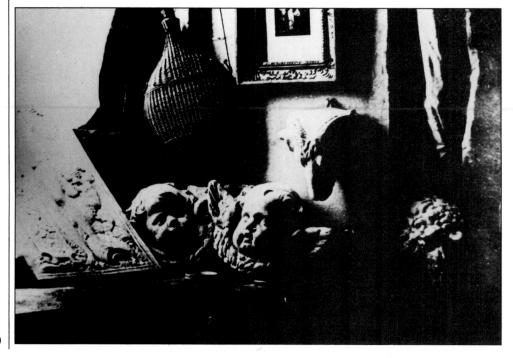

The first daguerreotype that survives, taken by Daguerre in 1837, is a still-life, showing a surprisingly wide range of tones and a wealth of fine detail in a wicker basket, a picture frame on a wall and a collection of artistic plaster casts.

Viewing a daguerreotype
In a daguerreotype the highlights are represented by a grayish deposit of silver-mercury amalgam, while the shadows are formed by the reflective surface of the plate itself. To see the image in its correct tones, it is necessary to reflect a black ground in the plate's surface (near left). When a white ground is substituted, the shadows appear unnaturally white (far left).

A simple pose and plain background typify the style of the daguerreotype portrait studios of the 1840s and 1850s. The portraits were displayed either in a hanging frame, as in this example, or in a folding case of leather or papier mâché.

Images on writing paper

The announcement of the daguerreotype in 1839 amazed and delighted the public, but one English scientist received the news with dismay. William Henry Fox Talbot had already produced what he called "photogenic drawings," and feared that Daguerre was poised to capture the fame that should rightly be his.

Talbot's process was the true forerunner of modern black-and-white film. He first soaked a sheet of fine-grade writing paper in a salt solution, then dried the paper and brushed it with silver nitrate solution to form light-sensitive silver chloride. When the paper was dry again, he loaded it into a camera and uncovered the lens. Prolonged exposure darkened the paper, leaving a negative image that Talbot stabilized with a strong salt solution.

Then he made a positive print by exposing the original to sunlight in contact with a second sheet that he had sensitized in the same way as the first.

From one negative, Talbot could in theory make many positives, whereas making more than one daguerreotype required an equal number of camera exposures. But the fibrous nature of paper negatives, noted Talbot, made his images "vague, foggy things" in comparison with Daguerre's silver plates.

Subsequent modifications improved sensitivity, sharpness and stability. But most spectacularly, Talbot found a method of sensitizing paper to create, after a relatively brief exposure, a latent image that was made visible by further chemical treatment, or what we would now call development. Talbot referred to this as the "calotype" process.

William Henry Fox Talbot
introduced his calotype process in 1841,
four years before this daguerreotype
portrait of him was taken by his friend
Antoine Claudet. The word calotype,
from the Greek, means "beautiful
impression."

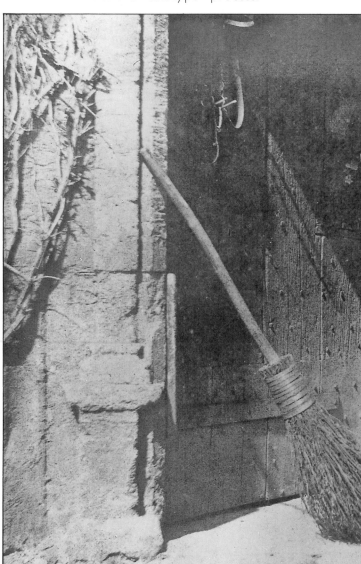

A lattice window in Lacock Abbey, Talbot's family home in Wiltshire, was the subject of his earliest surviving negative, made in 1835. The image, just one inch square, required an exposure of about half an hour on a sunny day.

A man in Indian dress (below) grasps the barrel of an exotic firearm in a calotype by David Octavius Hill and Robert Adamson, taken in their studio in Edinburgh, Scotland. These calotype artists, whose partnership lasted until 1848, were renowned for their ability to convey character in a portrait.

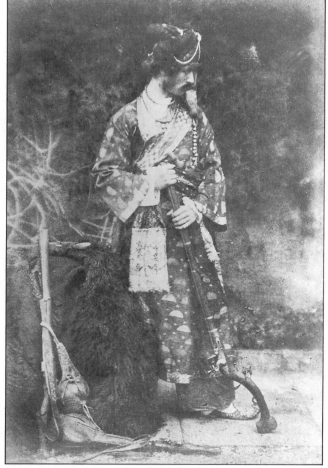

An open door (left) reveals a dark interior in a calotype of 1853, described by Talbot's mother as "the soliloquy of the broom." This was one of the plates in a published album of Talbot's calotypes entitled The Pencil of Nature.

23

A darkroom in a tent

In 1851 an English sculptor, Frederick Scott Archer, invented what he called the "collodion" process of making negatives on glass plates. In the next two decades this process largely superseded the calotype and the daguerreotype, because it combined the advantages of both: it produced a finely detailed image that could be reproduced in large numbers.

Collodion is a solution of an explosive, cellulose nitrate (guncotton), in alcohol and ether. Archer found that this viscous solution would adhere to a glass plate. After being sensitized in silver nitrate, the plate was ready to be exposed in the camera. However, the plate's sensitivity diminished quickly once the collodion began to dry. So the whole photographic process – coating the glass with collodion, sensitizing it, exposing the plate and then developing the negative – had to be carried out while the plate was wet. Indoors, "wet-plate photography," as it soon came to be known, was reasonably straightforward. But to take pictures outside meant transporting all the equipment for processing to the scene and setting up a darkroom next to the tripod as shown below. Undaunted, photographers brought back wet-plate images from exotic locations such as Egypt and the Himalayas and even from the battlefield, as the photograph on the opposite page at top illustrates.

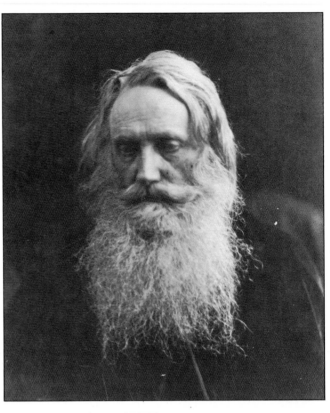

Wet-plate photography in the field
The photograph below, taken by John Thomson in about 1870, shows a photographer on location with his portable darkroom for making and processing collodion plates. In the illustration at right, a traveling photographer has strapped all this cumbersome equipment to his back. The complete outfit consisted of a camera and tripod, an opaque tent and frame for the darkroom, and a box containing the plates, chemicals and water for processing.

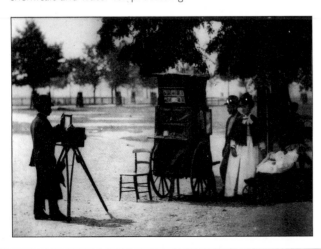

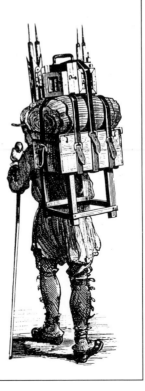

A portrait of the English poet and philosopher Sir Henry Taylor, taken on a wet collodion plate in about 1865 by Julia Margaret Cameron, exemplifies this great photographer's penetrating ability to capture a sitter's personality. Mrs. Cameron converted a henhouse on the Isle of Wight, England, to serve as a daylight studio for portraiture.

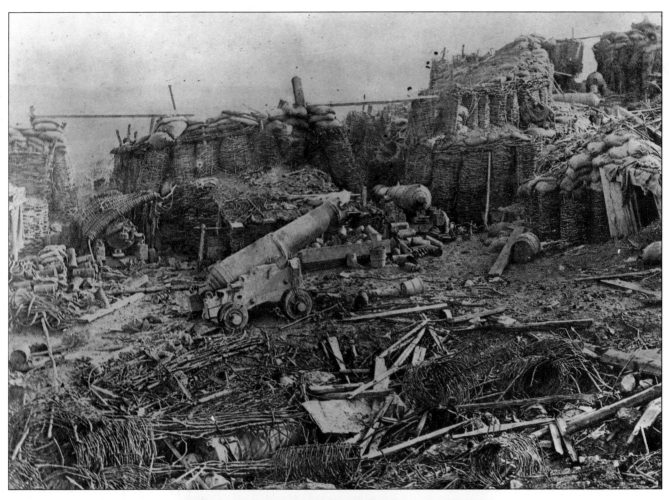

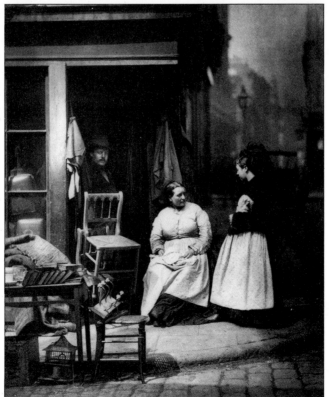

Cannons half buried in debris (above) mark the aftermath of a battle during the Crimean War. The photograph was taken by James Robertson in 1855, four years after the collodion process was invented. The greatly improved definition that the wet plate made possible helped nurture a growing interest in documentary photography.

Proprietors of an old furniture store (left) pass the time of day with a neighbor. This photograph was one of a series by John Thomson published in 1877 in Street Life in London, *a book about the London poor.*

Cheap prints on glass and metal

Many early photographers were adventurers who had given up their trade and were attempting to make a fortune out of the new craze for photography, in particular out of portraiture. In the cities, however, competition among portrait studios was intense. If the public would not, or could not, come to a photographer, he would often pack up his studio and travel great distances in search of work.

By the 1850s, such itinerant photographers were commonplace. Many of them made their photographs using specially adapted versions of Frederick Scott Archer's wet-plate process. By treating a collodion negative with a mercury compound, they whitened the image. Backing the glass plate with black fabric, paper or paint yielded an "ambrotype" – a positive image resembling a daguerreotype.

Even more popular, especially in the United States, was the "tintype" or "ferrotype" process, which dispensed with the need for the fragile glass plate. To make a tintype, the photographer coated collodion directly onto a black-lacquered metal plate, then sensitized, exposed and processed it as if

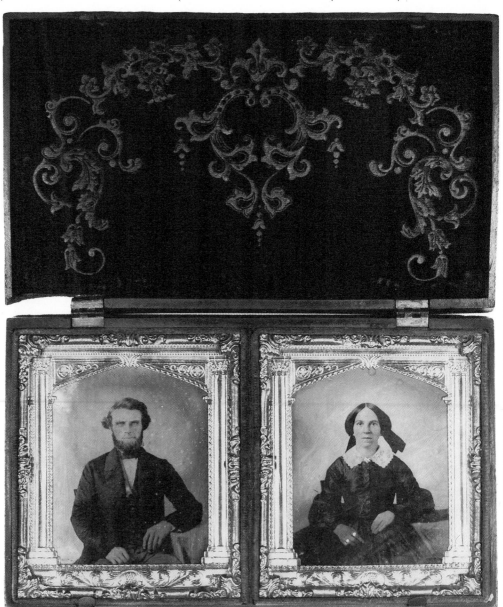

Ambrotypes
Ambrotypes were usually mounted in a decorative case, as shown at right. Like daguerreotypes, with which they are often confused, most ambrotypes are unidentified portraits, although outdoor scenes also exist. They were popular as an inexpensive substitute for daguerreotypes until the mid-1860s.

it were an ordinary wet plate. The resulting metal "print" was very resilient, and could be carried in a wallet or purse, without fear of damage.

Both processes were quick and inexpensive. Moreover, a novice could acquire the necessary skills by spending just one day at the elbow of an experienced photographer. Before long, photographic portraits ceased to be status symbols confined to the mantelpieces of the rich, and instead became a popular enthusiasm, accessible to almost anyone of modest means.

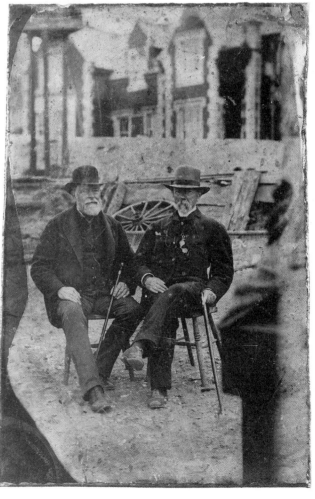

Tintypes
Tintypes, three examples of which are shown here, were usually of poorer quality than ambrotypes. Popular in studios in the 1850s and 60s, they were also adopted by street, beach or fairground photographers, and were made well into the 20th Century.

The manageable camera

At the end of the 1880s, photography was revolution-ized by a radical new material, the gelatin dry plate. The tedious routine of coating plates with collodion, then exposing and processing them before the surface dried, now became redundant, because photographers could buy plates ready-coated from a store. And because processing the new plates could be delayed for a month or more, photographers could travel more lightly, carrying just a camera, a tripod and plates: the cumbersome "portable" darkroom and apparatus could stay at

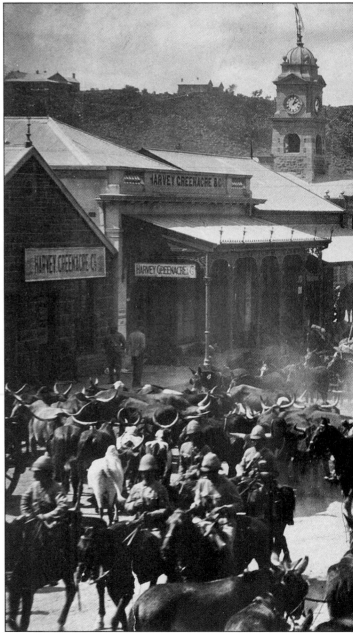

"The Dream" (above) is typical of
the romantic style of American
photographer Anne Brigman. Using dry
plates, she made many such nude studies,
often in desolate landscape settings.

home. With their burden of equipment cut in half, photographers were able to explore terrain impassable to those using the wet-plate process.

Dry plates had another advantage besides convenience. They were much more sensitive to light than their predecessors, so instantaneous exposures were a practical reality at last. Instead of covering the lens with a hat and removing it for an exposure of many seconds, the photographer now used a shutter to open and close the lens in a fraction of a second. On sunny days, exposures were so short that a tripod was unnecessary, and the hand camera, shown below, was born.

The dry plate changed the look of photographs dramatically. Gone were the blurs made by moving vehicles or animals, and the stilted outlines of figures ordered to "keep quite still." Instead, streets brimmed with life and activity, all frozen on film, as in the scene below at left. Portraits looked different, too, because rigidly fixed expressions were no longer essential. Now the sitter could relax, and the camera could catch a fleeting glance or smile.

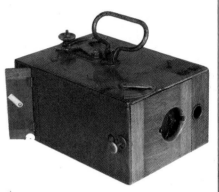

The first hand camera
Schmid's Patent Detective Camera (above) was the first commercially manufactured camera intended for use without a tripod. The term "Detective" referred to the camera's unobtrusive appearance, which the manufacturer claimed would make it suitable for candid pictures. It measured only $4\frac{1}{4} \times 6 \times 8\frac{1}{2}$ inches.

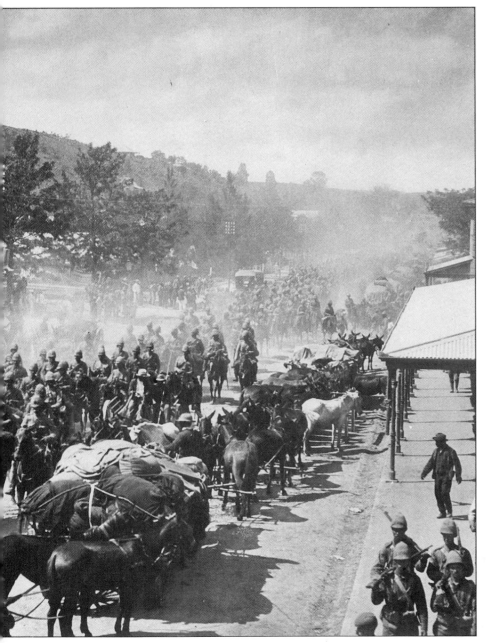

British cavalry stirs up a cloud of dust in a documentary picture of the Boer War. Until the advent of the dry plate, nearly all war scenes were either posed or devoid of living figures.

Routes to the print

The term "black-and-white" does 19th-Century photographs an injustice. Only a few are truly neutral in color. The examples on these two pages show only a fraction of the range of tones of these early prints. This range was due to the rich variety of alternative chemical processes used by 19th-Century photographers.

Enlargers of the modern type did not come into general use until the end of the century. Until then, negatives were contact-printed, much as proof prints are today. The photographer clamped the negative firmly against the paper under a sheet of glass in a special frame. He then made an exposure by simply propping up the frame in sunlight. Exposure time depended on the strength of the light.

At first, most prints were salt-prints: that is, they were made on plain writing paper soaked in salt and silver nitrate solutions, following the method pioneered by Fox Talbot. The paper slowly darkened in the sun to yield the image. These "sun pictures" had a reddish-brown hue, as shown in the example immediately below at left.

Salt prints retained the rough texture of the paper they were printed on. However, from the 1850s on, it was possible to achieve a smoother finish by using thin paper coated with a layer of salted egg white. Albumen prints, as they were known, remained popular until the end of the century. They had reddish-brown tones similar to those of salt prints, but to prevent fading they were sometimes toned with a gold solution, which gave the image a rich purplish-brown hue.

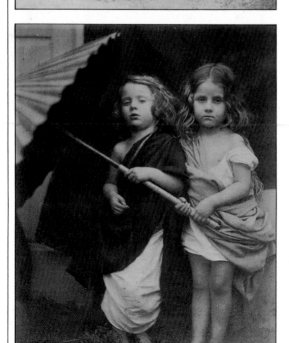

On the lawn at Lacock Abbey (left), the Fox Talbots pose for a relaxed portrait. This salt print, made by W.H. Fox Talbot in 1855, has the warm tones typical of "printing-out" papers – that is, papers that darken in sunlight to form an image.

Two children, one with an umbrella, are the subject of the 1865 albumen print at left by Julia Margaret Cameron. To make an albumen print, it was necessary to float the albumenized paper on silver nitrate solution to sensitize it before exposure.

The French canal scene at right is printed on carbon "tissue," a type of gelatin-coated paper that was sensitized with potassium bichromate and available in many colors. Some photographers combined tissues of different colors to create a multihued print.

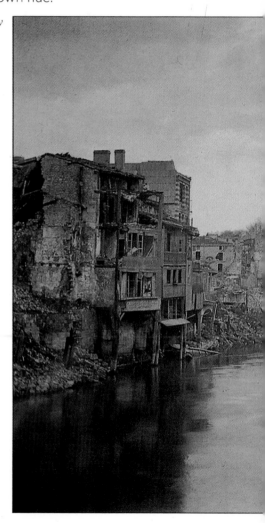

Many other processes were also in use, each suiting a different photographic style. For example, some photographers favored gum bichromate prints, which could resemble charcoal drawings, while others preferred the cool, even tones of platinum prints. Still others made prints by the carbon process, which produced the most stable image, virtually immune to deterioration, and was thus widely in use for book illustration.

Modern-style gelatin-silver papers were introduced in about 1880. These were development papers: that is, they were exposed briefly under a negative and then developed. Although an image on gelatin-silver paper was in black-and-white, photographers often toned prints in a variety of colors, most commonly sepia.

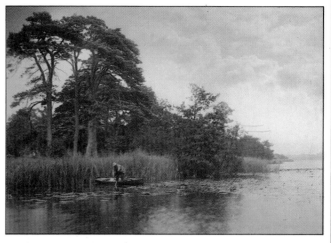

An English lake (above), photographed and printed by P.H. Emerson, shows the silvery quality of platinum prints. Although the paper was costly, Emerson, who was famous for his landscapes, felt that its rich tones were essential to his art.

A nude study (below) by French photographer René Le Bègue resembles a sketch. The print was made by the gum bichromate process: the photographer spread the emulsion, which contained pigment, onto the paper with a brush.

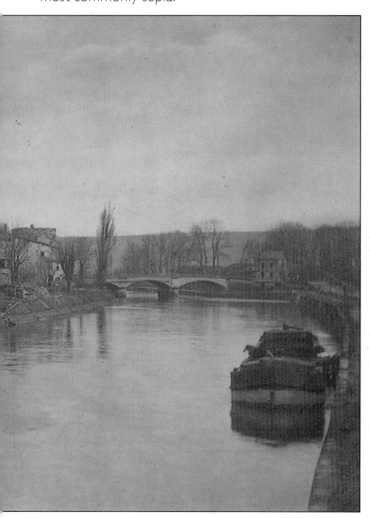

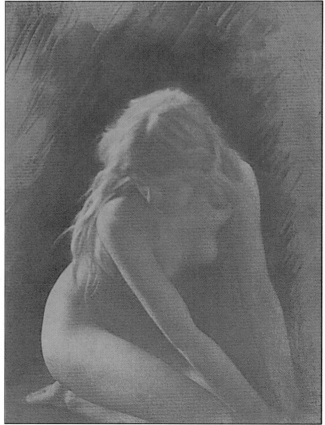

Snapshots for all

In the 1880s George Eastman, a dry plate manufacturer in Rochester, New York, introduced several innovations that revolutionized photography. The first of these, put on the market in 1885, was a system of coating light-sensitive materials onto rolls of paper instead of the heavy glass sheets of the dry plate process. Then, three years later, Eastman launched a novel camera that he trademarked "Kodak," an invented word he chose for its distinctive, emphatic sound. Essentially, the camera was a black box with a simple lens and shutter, fitted with a roll of paper long enough to accommodate 100 circular images. Instead of processing the film themselves, photographers sent the whole camera back to the manufacturer, who developed and printed the exposed film and reloaded the camera before returning everything to the user.

The Kodak camera marked the beginning of photography as we now know it. The camera was small and light enough to handhold and was unprecedentedly easy to use, with no focusing needed and no exposure settings to adjust. Eastman's advertising slogan summed up the process: "You press the button, we do the rest." Within just a few years, millions had answered Eastman's clarion call. Photography became a pastime available to all.

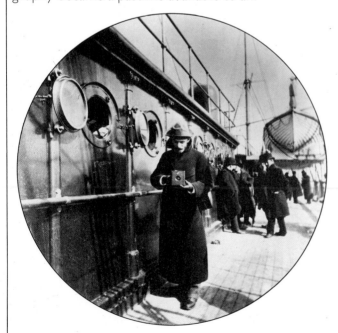

George Eastman stands with a Kodak
camera on the deck of the S.S. Gallia *in a
portrait of 1890, printed from a Kodak film
negative. The camera had a moderately
wide-angle lens and a fixed aperture.
The shutter was cocked by pulling a cord
and released by pressing a button.*

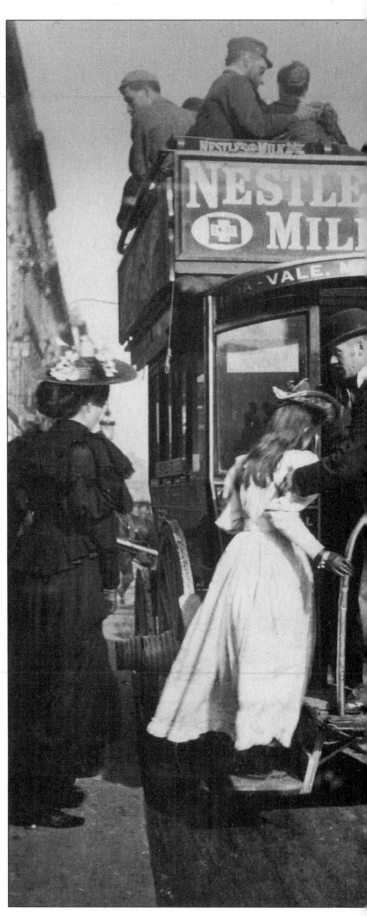

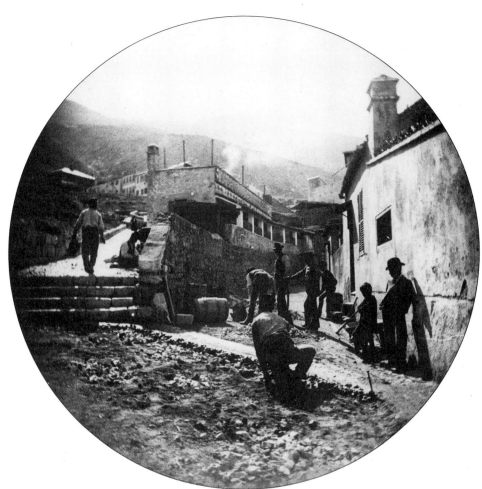

A street scene in Gibraltar (above), photographed in 1889 with an early Kodak camera, demonstrates the impressively high image quality of the first true snapshots.

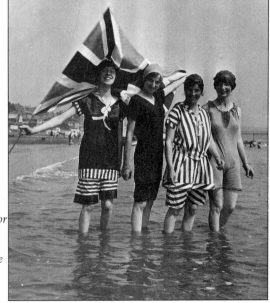

Four seaside bathers pose delightedly for a snapshot taken with a Kodak camera in 1910. The fixed shutter speed of 1/60 was fast enough to capture the spontaneity of the women's poses and expressions, with only slight blurring of the flag held by one of the bathers.

Boarding a London bus (left), a woman receives help in a snapshot taken in 1902. The waist-level viewpoint was typical of early amateur photography: the photographer composed the image by looking down at a viewfinder screen or a set of viewing lines on the camera top.

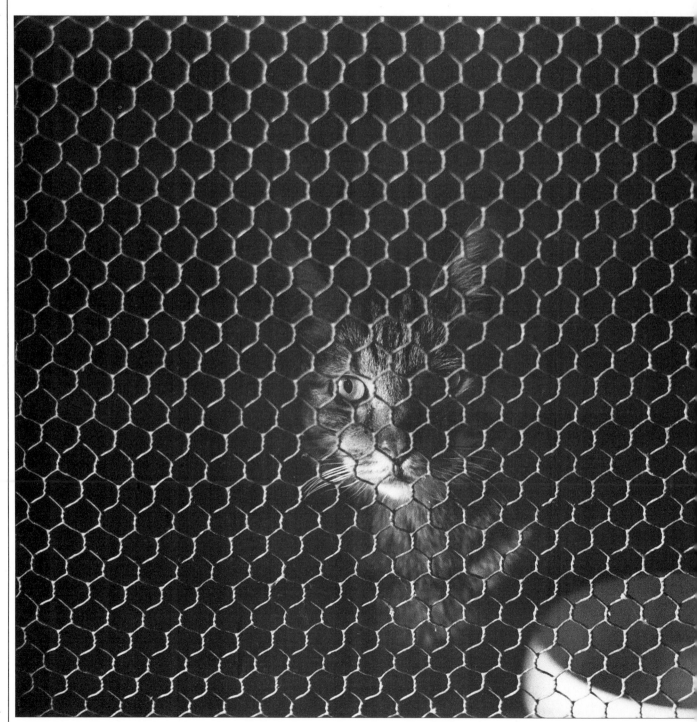

BLACK-AND-WHITE IN THE CAMERA

A world without color is a world in which one dimension of reality is missing. Yet in photography the absence of this dimension is by no means a loss, as the graphic image at left eloquently demonstrates. By taking photographs in black-and-white instead of color you simply exchange one creative medium for another. The potential of black-and-white as a distinctive and exciting way of interpreting the world should be clearly apparent from your very first roll of film.

To realize that potential you first need to shake off your habitual way of seeing and learn a subtler, more selective way. Once you have retrained your perceptions, you can go on to develop the special compositional skills essential to photographing in black-and-white and acquire techniques for judging exposure to get exactly the effect you want. To fine-tune your picture-taking you will probably want to experiment with films of different speeds and familiarize yourself with ways of controlling tones through filtration. And you may even wish to graduate to a large-format camera for finer rendition of detail.

Many photographers use black-and-white film to free themselves from the constraints of literal-minded realism and thus allow their imagination more scope. Others like the discipline it imposes or the possibilities it offers of conveying drama and atmosphere. Whatever qualities you discover in black-and-white photography, they are likely to become the basis of a lifetime's enthusiasm.

A cat in quarantine peers forlornly through a mesh fence in an image that uses bright highlights and deep shadow for a powerful effect.

Seeing in shades of gray

Using black-and-white film effectively means learning to see in shades of gray. And because we are so accustomed to color vision, ignoring colors in a scene may at first require considerable self-discipline and practice.

Most modern black-and-white films are panchromatic. This means that they respond to colors in very much the same way as the eye does and as an exposure meter does, giving equal emphasis to colors that are equal in tone (that is, equally light or dark) and are illuminated equally brightly. To clarify this idea, you may find it useful to take meter readings from a range of brightly colored objects. Whenever the meter indicates that two objects require

the same exposure, they will appear virtually the same shade on black-and-white film, regardless of their colors.

If you are familiar with color photography, you may need to revise your attitude to picture opportunities when you switch to black-and-white. Unless you mentally drain your surroundings of color, you will miss many excellent black-and-white images of the kind shown on these pages, and the pictures you do take may often be disappointing. A scene in which the colors jar with each other or fight with purely formal aspects of the composition can often produce a unified graphic image or a subtly atmospheric one when translated into monochrome.

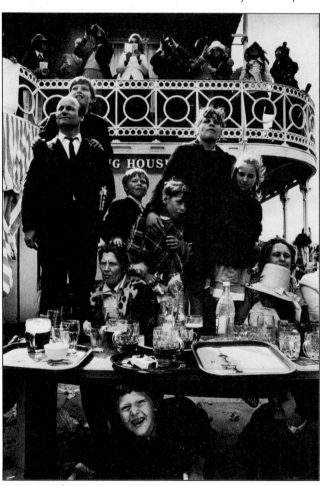

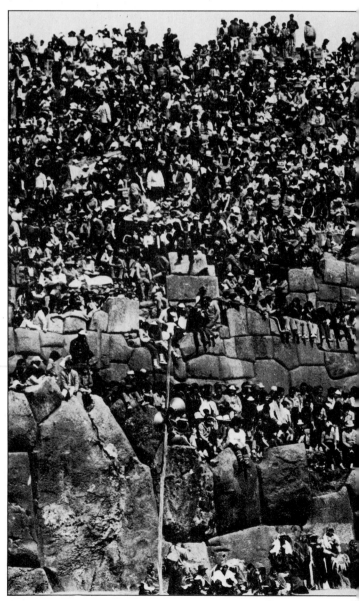

Spectators at a horse race
concentrate delightedly on the action.
Although complex, the scene is unified by
the three distinct bands of spectators.
In color, the wealth of different hues
in the clothes, the painted pavilion and
the trays on the table would have
produced too chaotic a composition.

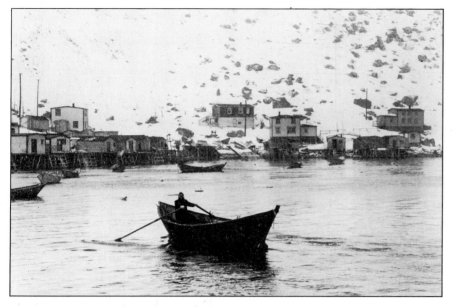

Approaching a harbor, a rowboat battles through snow. Black-and-white film emphasized the uncompromising hostility of a Canadian winter: if the photographer had used color film, the colors would have been attractively muted, but the sense of subzero temperatures would have been weaker.

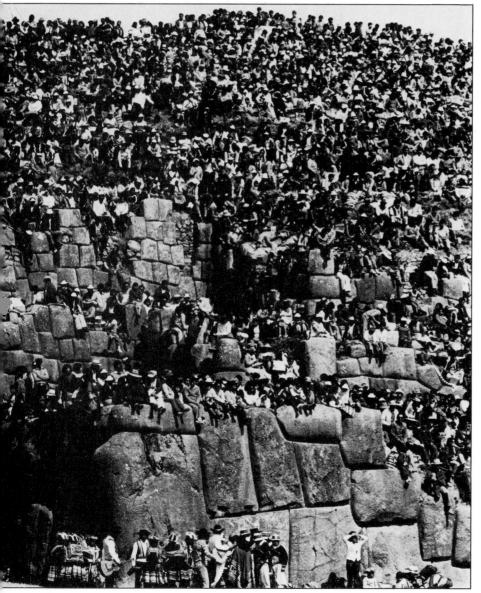

Peruvians cluster along the ancient walls of the city of Cuzco, waiting for a festival to begin. By using black-and-white film to blur the distinction between the stone blocks, the ranks of people and the grassy slopes they sat on, the photographer was able to create a graphic, semi-abstract effect.

Composing with tones

The key to composing a successful black-and-white picture is to judge carefully the relationships among the black, white and varying shades of gray within the frame. These tonal differences define shape and form and provide contrasts within the picture area. Unless you pay due regard to these factors, you run the risk that distinct parts of the scene will blend into one another to produce a disorganized composition. You can control tonal relationships to some degree during printing; however, this is no substitute for careful composition with the camera.

Before pressing the shutter release, make sure that each element stands out sufficiently against its background. For example, a tree bedecked with autumn leaves against a grassy hill may be an apt subject for a color photograph but may fail in black-and-white because the tones are too uniform. However, sometimes you may wish to use a deliberately restricted range of tones, as in the closely framed interior view below at left, where the tonal

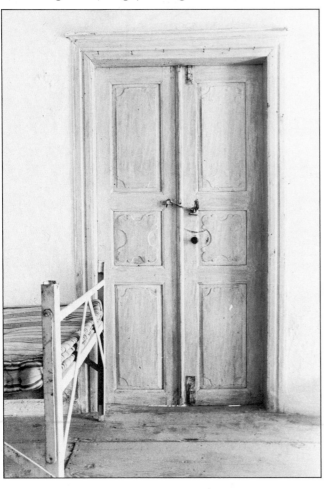

A detail of an austere interior presents a skilled orchestration of tones. Diffused sunlight from a window enriched the variety of tones without casting dark shadows. These would have ruined the picture's high-key effect, to which the striped mattress, the shadow on one bed leg and the black doorknob add a muted counterpoint.

gradations would undoubtedly have lost their subtlety in a color photograph.

The tones in a black-and-white print are affected not only by the inherent tones of the subject but also by the quality of the light. Small, hard light sources, such as a studio spotlight or a raking late-day sun, create black, hard-edged shadows and bright highlights, as in the picture below; flat, even lighting, on the other hand, reduces the tonal range of the image.

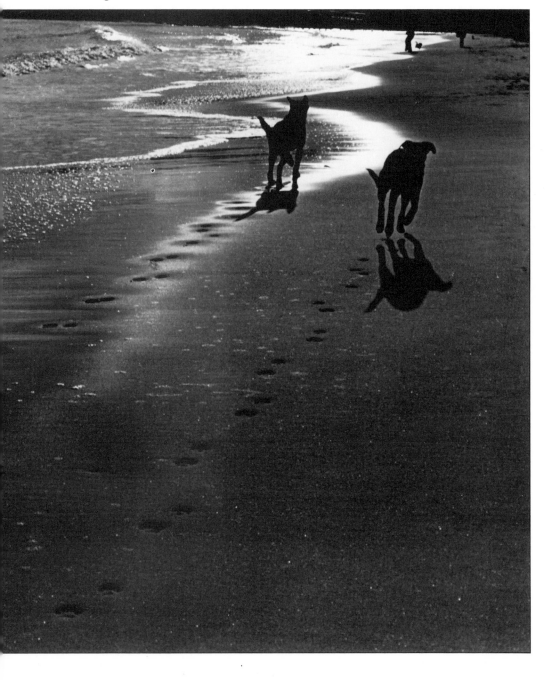

Two dogs *padding along a beach at the end of the day leave crisp pawprints. The photographer composed the view so that the lightest and darkest tones – the reflected highlights on the wet sand and the silhouetted dogs – formed a focal point in one corner of the frame. Tonal modulations in the sand and sea balanced the composition.*

Light and shade

Most black-and-white films have a wide exposure latitude, often as much as eight stops. Slower films have less latitude than faster ones, but even with a slow film, exposure errors have milder consequences than similar mistakes with color transparency film.

This broad exposure latitude results from the corrective measures that you can take in the darkroom. If the film is overexposed, the resulting negative will be too dark; but by prolonging the printing exposure, you can usually make an acceptable print.

Remedial action is less effective if the film has been underexposed because the shadow areas may contain hardly any silver image; however, printing on very hard paper can compensate for this problem.

Nevertheless, exposure control is important with black-and-white film, because the film is capable of recording only a limited range of illumination and gross exposure errors may cause bright or dark parts of the subject to fall outside these limits. Exposure is most critical when the brightness range of

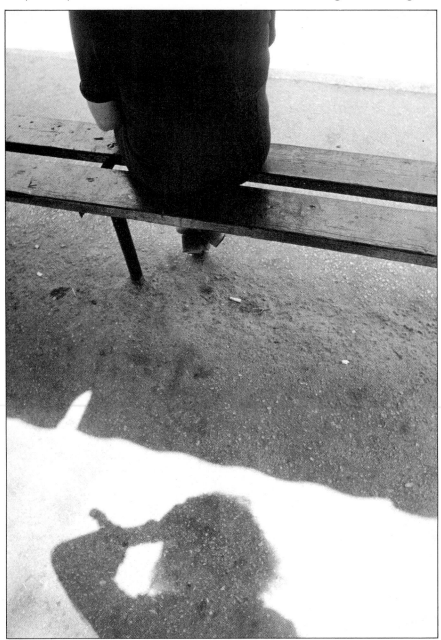

A bench in bright, sunlit surroundings creates a brightness range spanning eight stops, testing to the limit the film's exposure latitude. To avoid losing highlight or shadow detail, the photographer judged exposure by an incident light reading.

the subject is very wide, as in the brilliantly sunlit scene below at left or, for example, in a spotlit stage show. Even with corrective printing, exposure errors will sacrifice detail in either shadows or highlights, as the box at far right describes.

When the brightness range is low, as in the room shown below or in an outdoor scene in overcast weather, exposure is less critical. Errors will simply make the negative darker or lighter, but neither highlights nor shadows will fall outside the limits of the film's sensitivity to light.

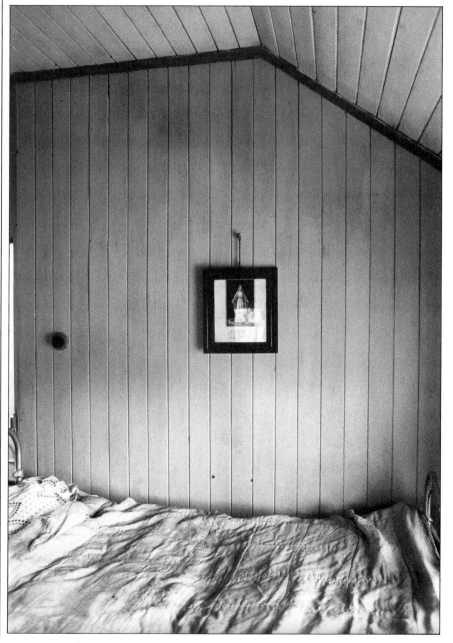

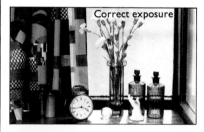
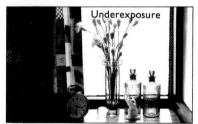

Exposure latitude limits
Correctly exposed film yields a print with detail and distinct tones in all parts of the image (top). Underexposure and overexposure can be corrected in printing, as here, but not without loss of detail in shadows and highlights respectively.

Correct exposure

Underexposure

Overexposure

*A **bedroom** lit softly from a window forms a low-contrast subject: the brightest highlight was just five stops lighter than the darkest areas. Precise exposure control was therefore not critical, and a straightforward TTL reading was followed.*

The zone system/1

Every photographic subject consists of a variety of brightnesses. When you press the camera's shutter release, you expose film not to a single light intensity but to many different levels of intensity – from the deepest shadow to the brightest highlight in the scene, with a subtly modulated range of brightnesses between the two extremes.

Light meters cannot take this range of exposures into account. They measure the light reflected from a selected area of the subject, and indicate the exposure that will accurately record this chosen area as a middle tone. However, in nine out of 10 situations the subject area measured is not a precise middle gray, and therefore exposure is not fully accurate.

The renowned California photographer Ansel Adams was dissatisfied with the inexactness of this averaging system of gauging exposure, and many years ago he devised a more precise method of exposure control: the zone system. Many creative photographers acknowledge that Adams' system is the most reliable as well as the most versatile way of measuring exposure on black-and-white film. The system, diagrammed below, divides the brightness range of a subject into 10 or 11 zones, numbered 0

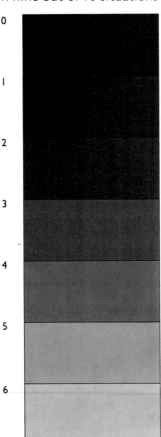

Zone 0 is solid black. On the negative, it appears as a clear, unexposed area, without texture or detail. — 0

Zone 1 is deep shadow in the subject. It is the first area showing any tonality, but there is no texture. — 1

Zone 2 represents the darkest part of the subject in which any detail can be seen. Texture is very slight. — 2

Zone 3 is the darkest tone in which detail can be clearly distinguished and texturing is adequate. — 3

Zone 4 falls within the range of medium tones. It includes average dark areas such as shadows in sunlight. — 4

Zone 5 is a middle gray – it represents a precise midpoint on the film's tonal range. — 5

Zone 6 is a medium light tone. Average skin tone or shadows on snow in sunlight will have this zone value. — 6

Zone 7 is a light tone, such as that of very fair skin. Good detail and texture are still evident. — 7

Zone 8 is white with some slight texture – for example, in highlighted areas of fair skin. — 8

Zone 9 is textureless white; no silver is formed so it prints as the white of the printing paper. — 9

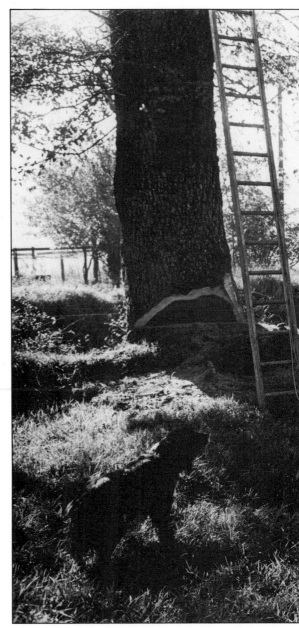

through 9 or 10. Each zone is one stop brighter than the zone with the next-lower number. The zones correspond to the tones that black-and-white printing paper can reproduce. At the lower end of the scale, zone 0 will record totally black; at the higher end, zone 9 will generally record pure white – the tone of the print borders. However, if large-format materials are used and exceptional care is taken in printing, zone 9 may show slight texture and may be distinguished from the paper white of a tenth zone. Of course, not every scene will contain the full range of 10 or 11 zones. Some subjects have an inherently narrow brightness range. For example, a foggy scene may have a range of only five zones: that is, the brightest highlight is only four stops lighter than the darkest shadow.

The great advantage of the zone system is that it enables a photographer to analyze and interpret light meter readings creatively, to suit the need and style of a particular subject rather than simply following the exposure indicated by the meter. And by assigning a tonal value to each part of the subject, you can accurately predict how its tones will appear in the print.

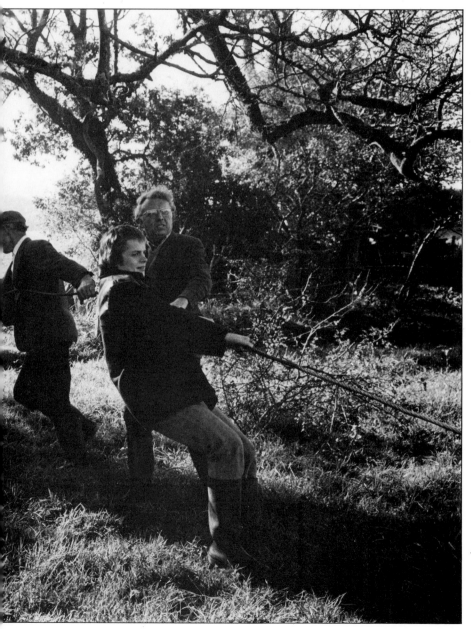

Three farm workers pull on a rope to bring to the ground a half-felled elm tree, blighted by disease. As diagrammed, the scene shows a broad range of tones, represented by zone system numerals between 0 and 9.

The zone system/2

Using the zone system may seem unnecessarily complex and time-consuming at first. However, once familiar with this method of calculating exposure, you have the satisfaction of much greater control over your images. The system enables you to make full use of the film's capability for recording light at both ends of the brightness range, so you can avoid loss of detail in the shadows and low contrast in the highlights. In the darkroom, a correctly exposed negative will save time and money, requiring fewer tests to produce a high-quality, richly toned print.

You can adapt an ordinary light meter to make zone system calculations easy, as the illustration at right shows. To use the system, you begin with a reading from a tonal area in which you wish to retain detail in the final image, and assign this a value on the zone scale. For example, you might choose a highlight area and place this in zone 8, the highest zone in which any texture will appear. Having assigned one area a tone value, as it will record on the print, you can take other readings and see where they fall on the zone scale, as demonstrated below. With this information, you can judge the best exposure for the subject.

Applying the zone system

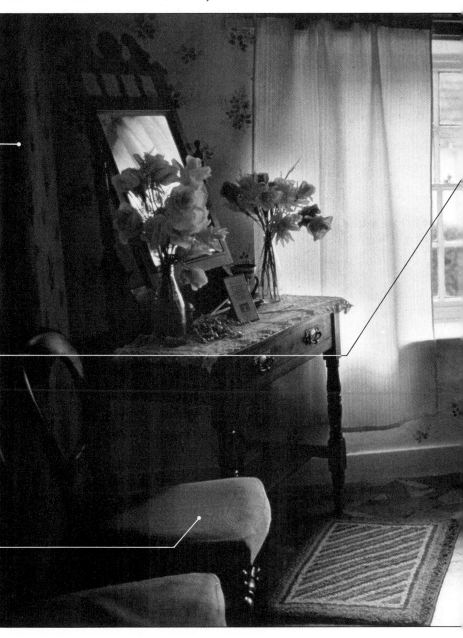

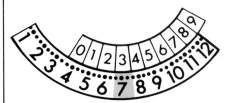

To apply the zone system in the scene at right, the photographer first took a meter reading from the darkest shadow area in which he wanted detail to appear – the wallpaper pattern behind the dressing table. The area registered 7, which he assigned to zone 3 on the zone scale.

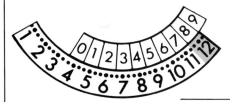

At the other end of the brightness range in this scene, the photographer took a reading from the window, registering 12 on the meter. This fell in zone 8, so he knew some detail would be retained.

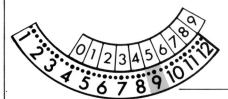

The final reading was taken from a middle gray tone – the seat of a chair. The needle swung to 9. This fell in zone 5, as anticipated.

Adapting a light meter
A conventional light meter can be easily converted to take zone system readings as well: draw up a zone scale on a strip of paper and fix this on the inside ring of the meter, as shown at left. In this example, the photographer took a reading from the deepest shadow in which detail is important, registering 5 on the meter. He then turned the inner dial until 5 lay opposite 2 on the zone scale, zone 2 being the darkest tone value that will print in any detail.

Matching film to task

Black-and-white film, like color film, has characteristics that vary with the film speed. To choose a film speed for a particular application you need to judge which is more important, the film's sensitivity to light or the print quality.

The slowest films in normal use, ISO 25 to 50, have extremely fine grain and excellent definition, and are thus ideal for recording detail or for images that will be greatly enlarged. When you are using a tripod, as the photographer did for the landscape below, light sensitivity is less critical, and you can use slow film even in dim light. Because the exposure latitude of slow film is low, and its contrast rather high, accurate exposure is important. Processing variations have more effect on slow film than on fast film, so more care is required in the darkroom, too. If maximum print quality is vital, consider using a dye-image film, as described in the box on this page, or an ultra-fine grain film such as Kodak's Technical Pan film.

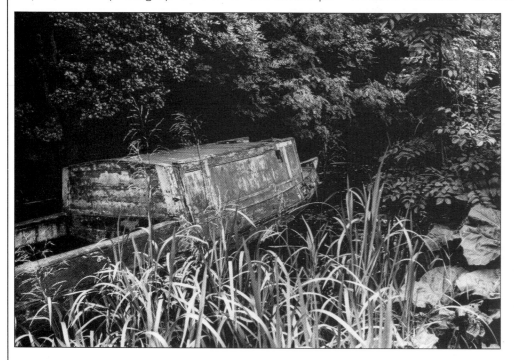

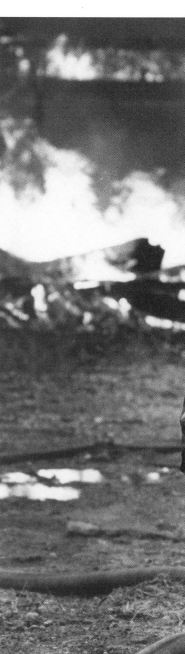

Dye-image film
Dye-image (or chromogenic) film has more in common with color negative film than with a conventional black-and-white emulsion. Dye couplers form a black-and-white image after processing in color negative chemicals by Process C-41. The film has enormous exposure latitude. Generous exposure produces ultrafine grain but leads to dense negatives that require lengthy printing exposures.

Conventional negative

Dye-image negative

Reeds and foliage (above) frame an old boat in an image full of the serenity of nature. The photographer loaded his tripod-mounted camera with ISO 32 film. The slow film revealed fine detail in the tangle of vegetation.

A fireman strides over hoses while a house blazes uncontrollably in the background. Even with ISO 400 film, the light was too dim for a normal exposure, so the photographer underexposed and subsequently push-processed. The pronounced grain in no way detracts from the power of the image.

Films such as Tri-X Pan with a speed of ISO 400 or faster have a larger grain size but several compensating advantages. Their speed permits the camera to be handheld even in low light. Contrast is relatively low and exposure latitude high, with an especially wide tolerance of overexposure, so that exposure control does not need quite so much care. All these qualities make fast film ideal for reportage, particularly in situations where the photographer may have to act quickly, such as the fire scene in the center picture here. Moreover, coarse grain can sometimes contribute to a mood of harsh realism or suggest a subjective view with overtones of memory or dream.

Films with a medium speed, between ISO 64 and ISO 320, provide a useful compromise between the two extremes. They are markedly less grainy than fast film but sacrifice only a stop or two of speed. The picture below shows how suitable a medium-speed film can be for showing detail in dim light.

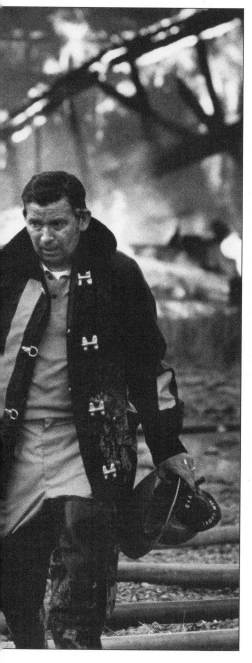

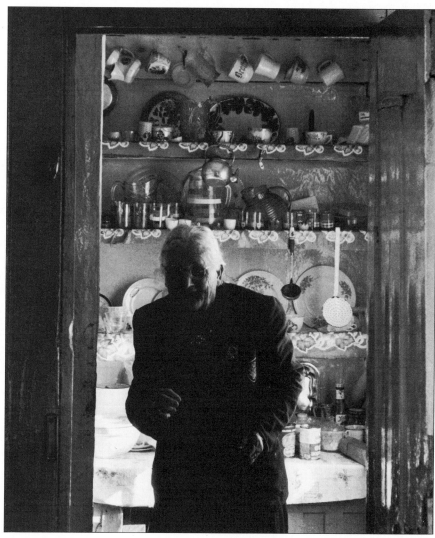

An old woman in the doorway of her pantry exchanges pleasantries with the photographer. Medium-speed ISO 125 film was ideal for this situation, where the kitchenware on the shelves and the woman's features called for a high degree of detail without too much loss of light-gathering capacity.

Large-format film

The 35 mm camera, light, small and simple to use, can take up to 36 pictures on a roll of film. By contrast, large-format cameras such as the one shown below are heavy and cumbersome, and take just one sheet of film, usually measuring 4 × 5 or 8 × 10 inches (10 × 12 or 20 × 24 cm). Yet some of the finest photographers, including such masters as Ansel Adams, prefer a large-format camera.

The main reason for this is the high image quality that can be obtained from a big sheet of film. In prints made from large negatives, grain is virtually invisible because any enlargement needed is usually slight. The 8 × 10-inch contact print opposite was made without enlargement and does full justice to the photographer's consummate understanding of tones and lighting effects. The rich, smooth tones in images from sheet film can make enlarged prints from 35 mm film look coarse by comparison.

Black-and-white sheet film offers other important advantages. Each negative can be given individual treatment; for example, adjusting development time to control negative contrast in a way that suits the subject and lighting conditions. With roll film, this is possible only if the images are of one subject. Another benefit for monochrome photographers is that large-format negatives can be printed by contact: no enlarger is needed, and as a result the image does not lose definition.

Moonrise over Hernandez, New Mexico, one of Ansel Adams' famous landscapes, was taken in 1945 on 8 × 10-inch film; as a result, the image – here printed same size – has superb sharpness and clarity, with rich shadow areas and pure highlights. Adams did not have time to look for his meter because of the rapidly changing light. But he judged the luminance of the moon and based exposure on that. His skill in judging tonal values enabled him to capture both the subtle details and the dramatic contrasts of the scene.

Large-format vs. 35 mm
The illustration at right compares the sizes of a 35 mm camera and a large-format camera taking 4 × 5-inch sheet film. The 35 mm negative (diagrammed below) is a fraction of the size of the 4 × 5 negative (shaded area). Whereas a 10 × 12-inch print from a 35 mm negative requires a 10 × enlargement, a 4 × 5 negative needs to be enlarged only 2½ ×.

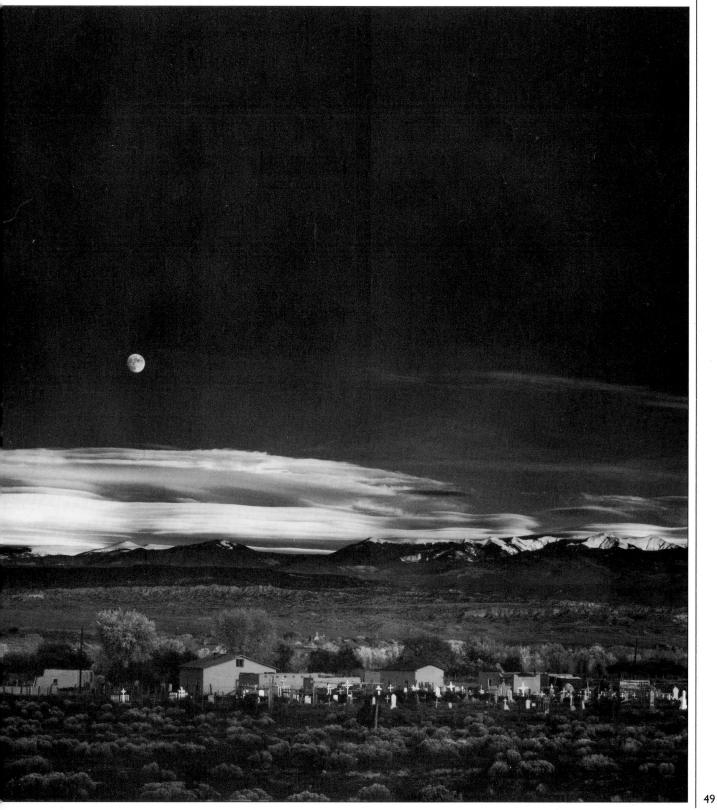

Filters for tone control

Since black-and-white film records all colors in shades of gray, it may seem surprising that photographers working with black-and-white at times use color filters. What possible effect can a filter have? To understand this apparent paradox, it helps to look at how filters work. A colored filter transmits light of its own color and absorbs light of a complementary color. Other colors are also absorbed, but to a lesser extent. For example, a blue filter allows all blue light to pass but absorbs yellow strongly. Red and green light will be absorbed much more than blue light, but less than yellow.

Bright painted stripes on a fishing boat (above) appear in their true tonal relationship when photographed on black-and-white film without filters (below).

A red filter darkens the sky above the boat – and the shadows below – almost to black, and lightens the red stripe. The yellow stripe records as slightly paler.

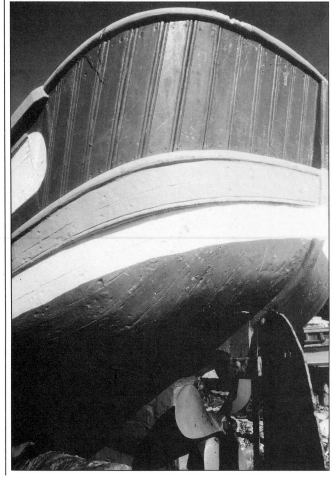

Fitting this blue filter over the camera lens has no effect on blue parts of the image, so these appear as normal in the negative. All other colors, though, cause less exposure on film, so they appear darker on the print. Darkest of all will be the yellow-colored parts of the subject.

Since all other colors are darkened, and blue is unaffected, blue areas will appear lighter by comparison. This is particularly noticeable if the photographer gives extra exposure to compensate for the light absorbed by the filter.

Because they offer photographers the ability to darken and lighten colors at will, filters are among the primary controls in black-and-white photography. One practical example of their value is in photographing flowers. Though the bloom and leaves of a flower are often very different hues, they are often the same tone, and a black-and-white photograph will render both areas as a similar shade of gray. For instance, in a monochrome print, red roses often merge into the dark green leaves around them. But with a red filter over the lens, the bloom will look lighter and the leaves darker, giving the picture more impact and depth.

A yellow filter – the most popular filter for general photography – darkens the sky but records the red stripe in almost the same tone as in the unfiltered image.

A blue filter has almost the opposite effect of red. Blue sky and paintwork look very pale, and the red and yellow stripes both appear considerably darkened.

Ultra-fine grain with 35mm film

Conventional 35mm black-and-white film, even the slowest available (ISO 25), cannot match sheet film for even tones, fine grain and high resolution. However, there are some special types of 35mm film that produce high-resolution negatives, capable of great enlargement with minimum loss of quality.

The most widely available film of this type is Kodak's Technical Pan 2415 film, which was formulated for special scientific applications, as its name suggests. Technical Pan film is capable of a wide range of contrasts, depending on the developer you choose and on the development time you allow. For simplicity in processing, Kodak Technidol LC developer is the best choice, as explained below.

To make the most of this film's almost grain-free performance, choose subjects that have a wealth of fine detail, like the church on the opposite page. Set your camera's film speed dial to ISO 25, and bracket to be sure of getting a correctly exposed image. As with all slow film, you will often need to mount your camera on a tripod, particularly when using small apertures that demand long exposures.

The color response of Technical Pan film is rather different from that of ordinary black-and-white film; it has a higher than usual sensitivity to red light, which means that it responds particularly well to red filtration. For example, with landscapes, a red filter will effectively eliminate most haze. With portraiture, this sensitivity to red can help disguise skin blemishes. In tungsten lighting, flesh tones may appear too light; you can correct this by using a pale blue filter.

Processing Technical Pan
To moderate the inherently high contrast of Technical Pan, you must use a specially formulated developer. You can mix this yourself from raw chemicals, but a more convenient way, particularly for occasional users of the film, is to use Kodak Technidol LC developer. When diluted, the contents of one packet make enough solution to process two rolls of 35mm film. To get the best results, carefully follow the directions included with the chemicals. Don't be tempted to cut corners, as this could yield uneven negatives.

A country church (right) catches pale winter sunlight. In order to produce a negative that could be enlarged to mural-sized proportions (4 × 3 feet), the photographer loaded his camera with Technical Pan film, using a red filter to darken the sky. A 25 × enlargement (below) showed little grain and good definition; on ISO 125 film the image looked much less crisp when the negative was similarly enlarged (below left).

A boy sits in front of a giant portrait of himself, which shows one of the many applications of Technical Pan film. The photographer developed the film at home using Technidol LC developer but had the enlargement made professionally.

Conventional ISO 125 film

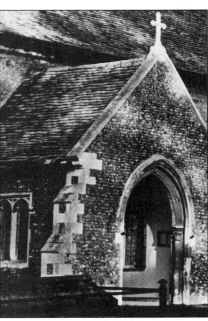

Kodak Technical Pan 2415 film

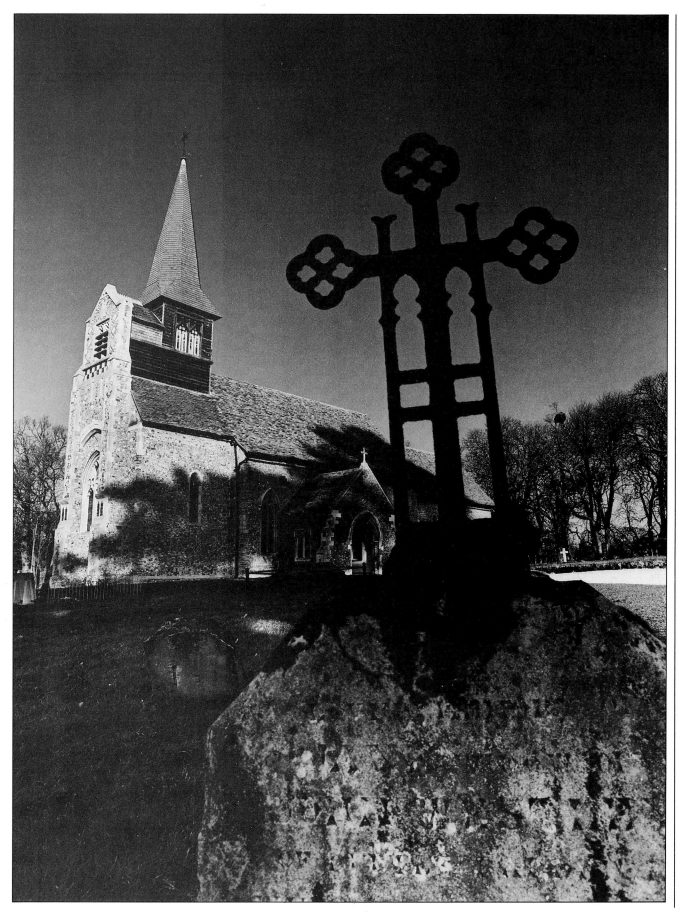

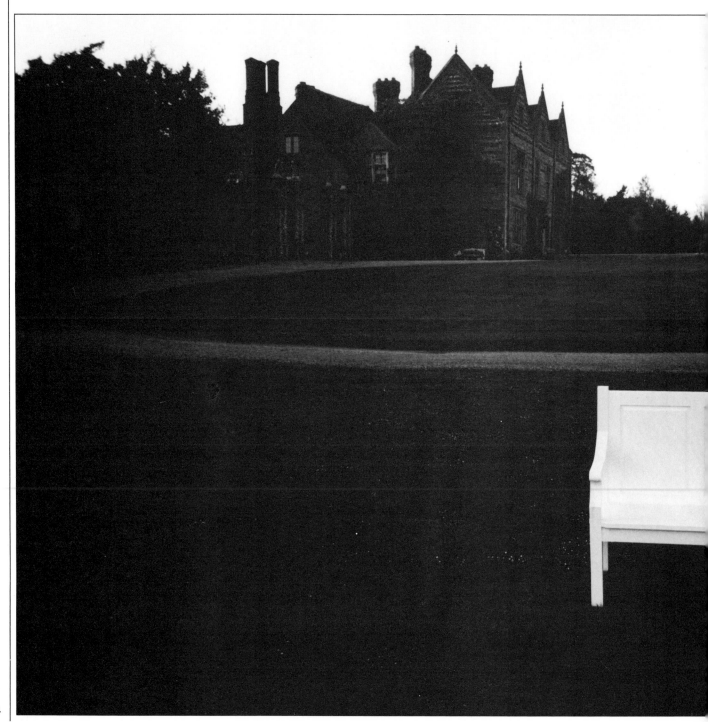

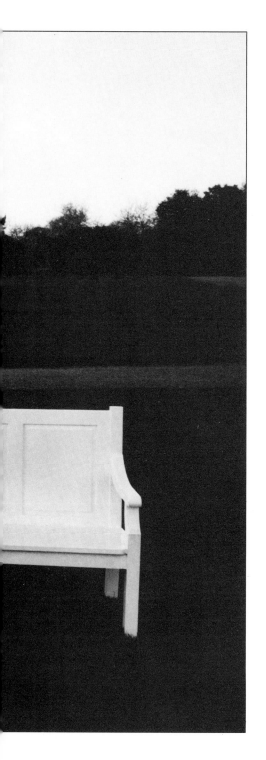

CLASSIC SUBJECTS IN BLACK-AND-WHITE

To create a fine picture in black-and-white is to affirm a powerful link with the great photographic traditions. Although the equipment, materials and techniques of black-and-white photography have evolved over time, in principle they are little different today from those employed nearly a century ago.

Because of this continuity with the past, it is hardly surprising that photographers who use black-and-white film are often drawn to the classic subjects of the medium. The following section examines these traditional themes – landscape, portraiture, the nude, still-life and reportage – and shows how many of the qualities inherent in such subjects can be enhanced by the purity of vision that black-and-white offers.

Whatever theme you choose, there are special approaches to film choice, composition, lighting, exposure, filtration and printing that can lift your images to the high level of excellence displayed in the garden landscape at left. You can develop these skills in your own way, and even apply them to subjects that do not fall quite so squarely into traditional categories.

A white bench stands out against the dark lawn of a country house. The photographer used a spot meter and exposed for the bench, creating a dark background for added drama.

Landscapes/1

Black-and-white prints have a restraint and formality that are particularly suited to the subtle tones, textures and contours of landscapes. Since he usually has plenty of time to compose the picture, the landscape photographer can adopt a studied approach to achieve exactly the effect he wants.

All three pictures here exemplify, in contrasting ways, the complete control over tones that is so important in landscapes. It is worth using the zone system to find the right exposure. To meter a small, distant area, either use a spot meter or find a nearby area of similar tone and take a reading from it with an ordinary meter.

Working in the right light and weather is even more important with black-and-white than with color film. In black-and-white, light and shade can be vital to reveal form. Conditions are ideal when the sun is low and bright, as in the picture below. Sunny, windy weather with broken clouds is excellent: it creates attractive patterns of light and shadow that move quickly over the land, changing tonal relationships to provide a wealth of picture opportunities.

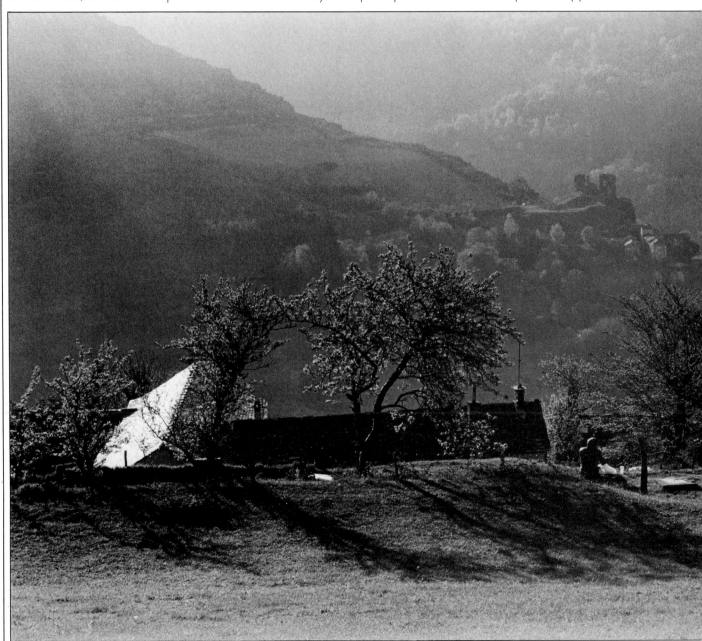

A French hillside (below) catches the raking afternoon sun, which casts long shadows on the grass and brilliantly outlines the trees, posts and seated figure, separating them clearly from their background. At noon the scene was less photogenic, with small shadows and a haze that obscured the distant trees and buildings.

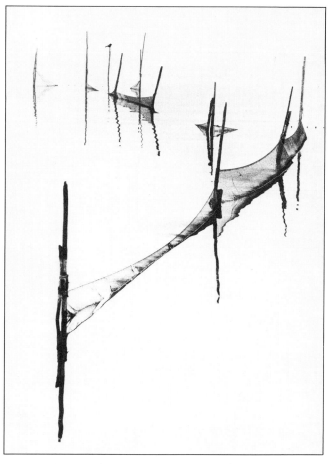

A curve of fishing nets strung from wooden poles and reflected in the gently rippled surface of a lake makes an almost abstract study, with a spareness and simplicity that would be hard to match on color film. By push-processing, the photographer increased contrast and grain, reducing the image to its bare essentials.

A long, straight road in a flat landscape may seem an unpromising subject, but for the image below, the photographer exploited the dramatizing qualities of black-and-white film to make the most of billowing clouds grazing the horizon. To exaggerate the drama he used a polarizing filter, which darkened the tone of the sky.

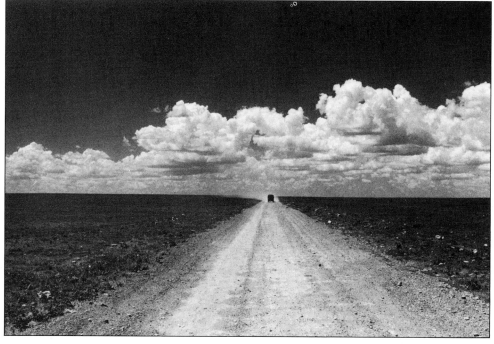

Landscapes/2

One excellent way to increase contrast and separate tones in black-and-white landscape photographs is by using filters. The colored filters for black-and-white film lighten the tones of corresponding hues, and darken the complementaries of those hues. Most useful are the yellow, orange and red filters: as demonstrated below, these absorb blue light and thus darken blue skies. Because the sky's tone is darker, the patterns of clouds stand out; the deeper the blue of the sky, the more intense the effect. But, if the sky is not blue, adding a filter simply forces you to give the picture more exposure.

Apart from adding interest to skies, filters can also lighten or darken land areas to provide greater detail or tonal contrast. For example, red or orange filters increase texture in wood, sand or snow that are sunlit from a blue sky. In seascapes, an orange filter darkens the tone of the water so that it does not merge with the sky. The filter factor given by the manufacturer indicates the exposure increase necessary. For critical results you can work out your own filter factors by making exposure tests. Because filtration increases the contrast of the negative, remember to expose for the shadows in a scene.

Without filtration

Yellow filter

Orange filter

Red filter

Filtered landscapes
The pictures above show the effect of different filters on the same monochrome scene. With no filter (top left) the sky appears flat. A yellow filter (top right) darkens the sky but retains realistic contrast. With an orange filter (bottom left) the clouds stand out more brilliantly. Finally a red filter (bottom right) absorbs almost all the blue light to create a dramatic dark sky.

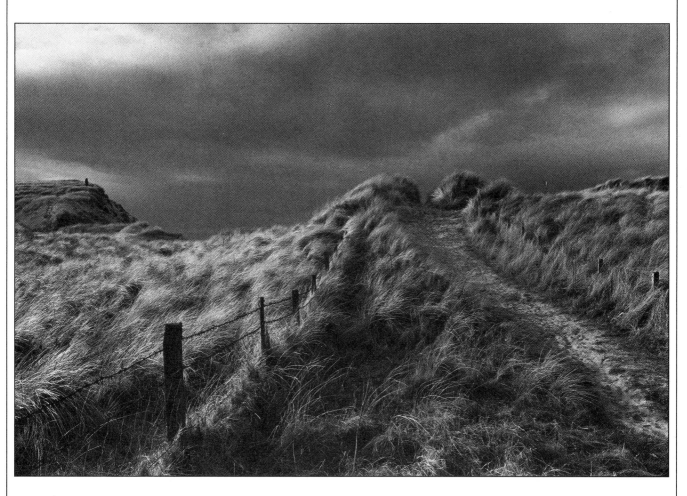

A wild cliff-top landscape in
*Caithness, in the north of Scotland, has
a bleak, windswept mood that the
photographer intensified by using a wide-
angle lens and a yellow filter. Because
the sky was cloudy, filtration did not
have a darkening effect on it.
However, the yellowing tussocks and
the sandy path leading to the beach
recorded in lighter tones, increasing
their textural detail.*

Portraiture/1

The comparatively wide tonal scale of black-and-white film and the ease with which contrast can be controlled in the darkroom give the photographer great versatility. This is a considerable advantage in portrait photography, where too much contrast can lead to harsh, unflattering results in color. For example, in the picture below, fairly hard, contrasty lighting has produced a print with a rich range of tones: in color, these would divide into stark dark and light areas.

The tonal extremes of low- and high-key images are also easier to achieve in black-and-white: with color film, the continuity of tone on which these extremes rely for their impact is less evident in pictures where the hues themselves can be distracting. For low-key images, you should choose a dark-skinned or dark-haired model and use lighting to separate the sitter from the background if your meter reading shows that the tones are too similar. For a high-key effect, you will need a more elaborate lighting arrangement so that you can virtually eliminate shadows. The lights should be diffused and

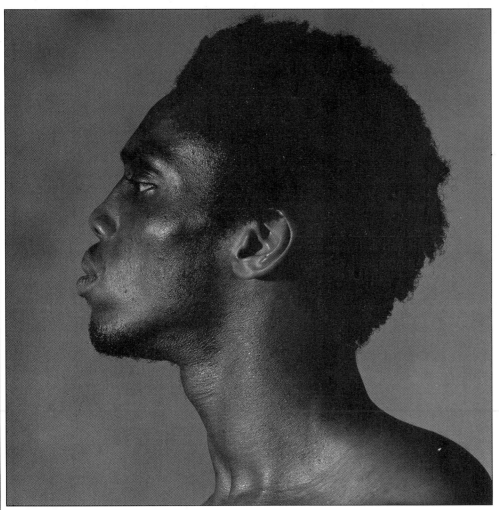

The profile *above was given a low-key treatment that suits the subject's mood and coloring. A plain, dark background, and a tungsten photolamp positioned to the left of the subject, threw the contours of his head into relief while retaining the subtlety of tones.*

placed close to the camera, with plenty of fill-in lights and separate lighting for the background, which otherwise will appear gray rather than white. Catchlights – reflections of a light source – in the eyes are especially important in images such as the one below, adding sparkle and a tiny element of contrast to act as a focus of interest.

Both high-key and low-key portraits can be improved with darkroom techniques. You can burn in to darken unwanted pale areas, and dodge or shade to lighten shadows.

***The high-key portrait** below gains from the simplicity of black-and-white. The choice of set, an interesting pose and off-center framing prevent the pale tones from looking bland. Five photolamps produced soft, diffused lighting. To remove shadows from under her chin, the model held a white card reflector.*

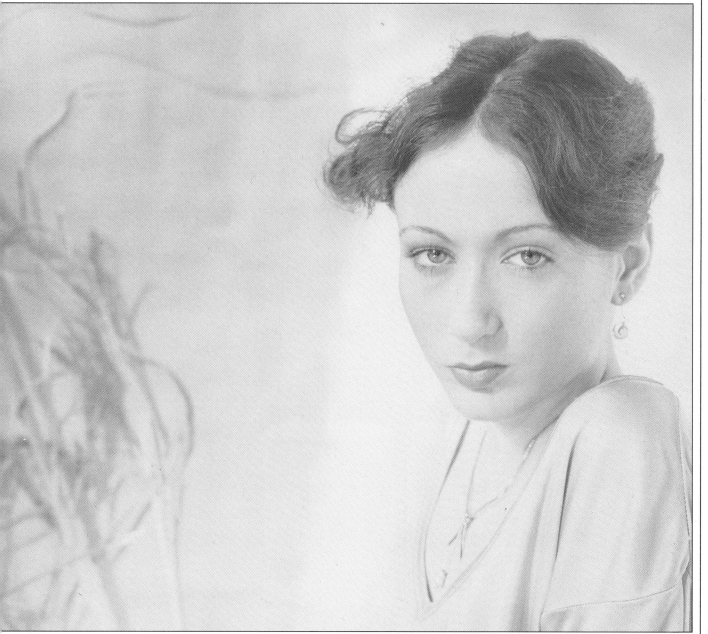

Portraiture/2

The tonal qualities of a film have special significance in portrait photography. Even if the subject's head occupies only a small part of the picture area, our eyes are drawn immediately to the face, and we tend to pay particular attention to the way the film records the texture of skin.

Film type and format dictate how prominent the grain will be, and how smoothly tones will change from dark to light. Thus, the choice of film can pro-

foundly influence the way the subject's face appears. Medium- and large-format films (roll and sheet film) produce a grain that is almost invisible at normal enlargements; moreover, because a relatively large amount of silver is used to record the picture, tones are well separated and smooth, as in the image below. The result is a richly detailed, sensuous yet mysterious portrait.

Although 35 mm films are technically capable of

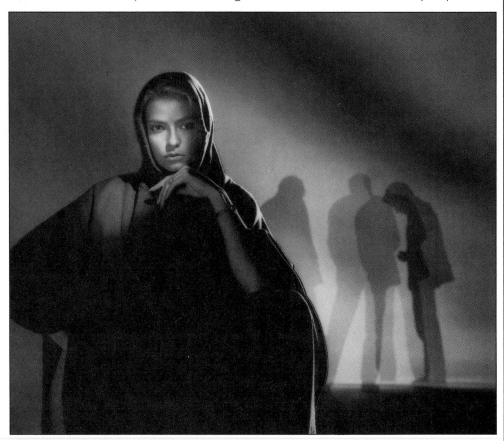

The somber atmosphere of a dark portrait lit by electronic flash relies on a very full tonal scale, which the photographer achieved by using slow film in a medium-format camera. To create the shadows behind the figure, he left the camera's shutter open, moved behind the backdrop, and fired a small flash unit at it several times, shading the flash with his own body.

Blue filter

Green filter

Orange filter

Filters for portraits

Because skin hue is much more muted than that of, for example, blue sky, filtration plays a less important role in portraiture than in landscape. Nevertheless, you can control skin tones to a limited extent with filters. The faces in portraits made by the warm light of tungsten lamps may look pasty and unhealthy: a blue filter corrects this (far left). A green filter adds a "suntan" to faces in outdoor portraits (center), and, conversely, an orange filter helps to lighten faces (left), removing small blemishes.

producing portraits of almost equal richness and luminosity, they require more care than roll or sheet film, because the film area is so small. If you want a smooth result, choose a very fine grain film, such as Kodak Technical Pan or Panatomic-X, or a dye-image film. Compose the image precisely in the viewfinder, so that little enlargement is needed and you make maximum use of the film area.

With 35 mm film, you may choose to accentuate the grain in order to create an image that has striking tonal qualities. Exaggerating grain by using fast film and increased enlargement produces a stylized portrait that downplays the role of facial expression and emphasizes atmosphere, environment and pose. For example, in the picture below, the dancer's makeup conceals her face like a mask, and the picture's grainy appearance and rough tonality serve to exaggerate this impression.

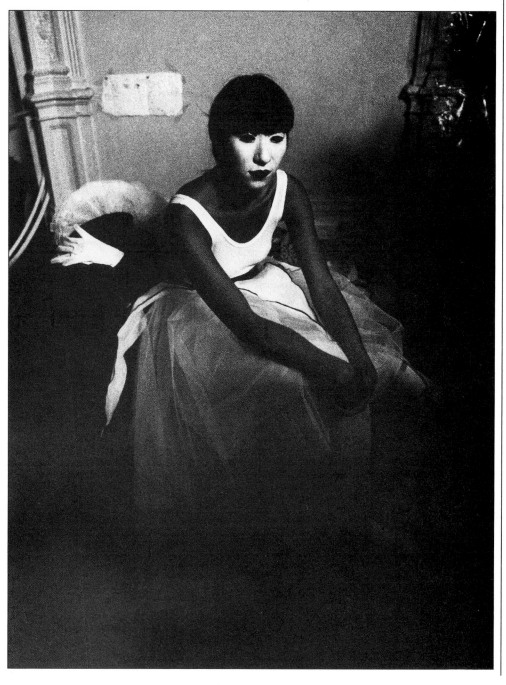

Gritty realism pervades this portrait of a dancer, taken while she waited for her cue. The relatively coarse grain of ISO 400 film was exaggerated by push-processing.

Still-life/I

Still-life subjects offer an ideal introduction to the basic techniques required in black-and-white photography. In an improvised home studio, you can take as much time as you need to set up your pictures, experimenting with a variety of props, viewpoints and lighting arrangements. And because black-and-white processing is quick and easy, you can expose a roll of film, process and examine the negatives, and then return to the set to make any adjustments necessary for getting exactly the images you want. Such rapid feedback will quickly enlarge your understanding of how black-and-white film behaves.

Choose subjects that have an interesting shape or texture, and bear these qualities in mind when planning groups. Never be afraid to use everyday objects like pen nibs and paper clips, kitchenware, or objects found in the garden. As the pictures on these two pages show, mundane items lose some of their familiarity in black-and-white, especially when the distancing effect of monochrome is emphasized by a novel juxtaposition or viewpoint.

With brightly colored subjects, you can sometimes improve the image by using a filter to alter tonal relationships. Extreme filtration – for example, a green filter that makes a red object look black – usually appears more acceptable in an artistic studio still-life than it would in a more natural image like a portrait or landscape.

Remember that the absence of color may alter compositional balance, giving more weight to the highlights in a low-key image and to the shadows in a high-key image. For example, in the composition opposite, the highlights on the corners of the box would be less prominent in a color view because of the dominant red of the apple.

Select backgrounds that show a contrast of textures or tones. On slow film, even a subtle textural difference between two kinds of surfaces can make a major creative contribution, as demonstrated in the two pebble studies below.

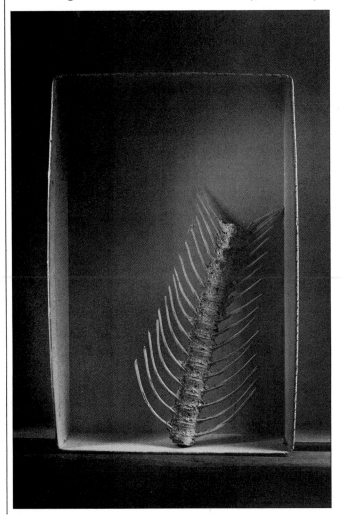

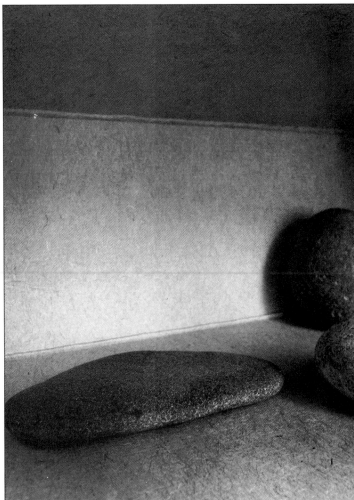

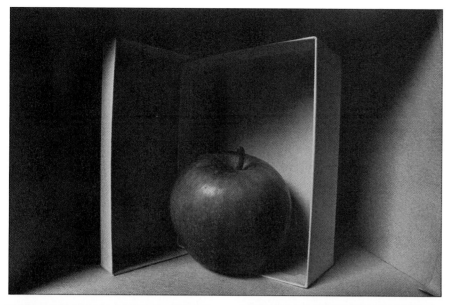

Pebbles and cardboard boxes constitute the chief elements in this selection of still-lifes by Erich Hartmann, all taken by available light from a window. The woven texture of the cardboard contrasts subtly with the granular pebbles, and more strongly with the shiny apple and knobby fish bone. The naturalism of color would have made the close-up below seem overwhelming and the apple picture at left seem brash, like an advertising image. But black-and-white gives these two pictures a quiet strength that harmonizes with the other images shown.

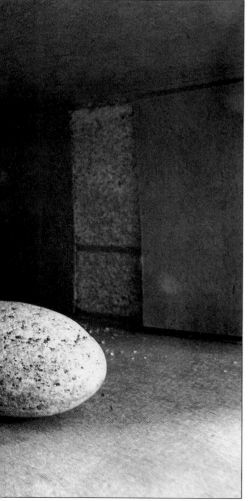

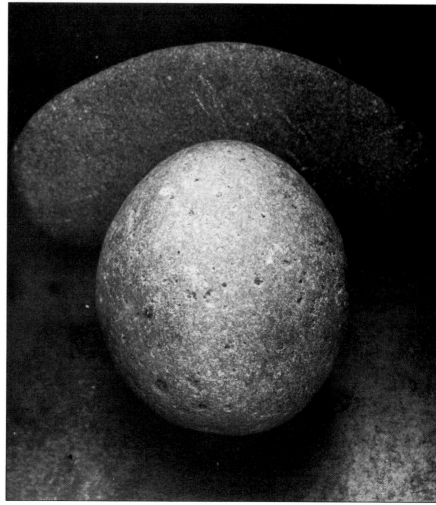

Still-life/2

The different approaches to the classic theme of a flower arrangement shown on these two pages both demonstrate how you can heighten the impact of a black-and-white still-life by careful choice of lighting.

Lighting should be harder, crisper and more contrasty than would be normal for a subject photographed in color. Black-and-white film records a wider range of brightnesses, so low-contrast lighting, needed to retain shadow detail in a color still-life, usually looks too flat in monochrome. You should make the lighting more directional than you would for a color image. To do this, move the lamps back from the subject, use smaller reflectors on the lamp heads, or reduce the diffusion between the light source and the subject. To fill in shadows, use weaker lamps or, if you are accustomed to foil reflectors with color film, replace them with white cards. If you normally use white cards anyway, use smaller ones, or move them further back. Alternatively, substitute pale gray cards for white.

Color temperature is irrelevant in black-and-white photography, so you can mix light sources freely – for example, using a window as the main source and a tungsten table lamp to fill in the shadows. Unless your subject is uniformly dull and mat in texture, you can often strengthen a composition by directing a hard light source at a reflective part of the subject to create a brilliant highlight, as in the picture below. Use obliquely angled lighting to bring out textures.

Because of the long tonal range of black-and-white film, creating pure black or white backgrounds can be difficult. For a rich black, hang a black velvet sheet some distance behind the subject, making sure that the subject lighting does not spill onto the velvet. With a white paper background, take separate meter readings from the subject and the paper; unless the background is about two stops brighter, it will come out gray, although this is not always a disadvantage, as shown opposite.

With black-and-white film, the best tonal separation occurs in the grays. If you want detail at the brighter end of the scale, underexpose so that the brightest tones fall in the middle of the film's tonal range; cutting the printing exposure will restore the extreme highlights to white, but with better highlight separation than if you had exposed normally. But remember that this gain in highlight detail comes at the expense of details in the shadows.

Conversely, if you want good tonal separation in the darker parts of the subject and are prepared to sacrifice highlight detail to achieve it, give more exposure than the meter indicates. To be sure of getting the best result, it is wise to bracket.

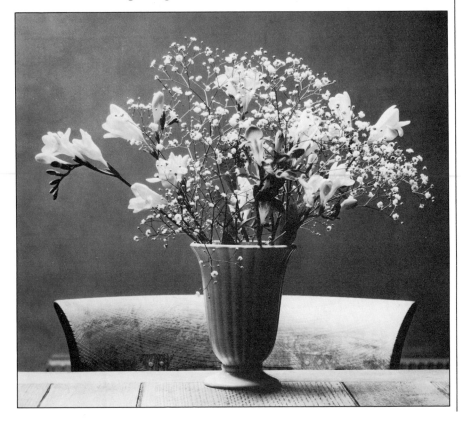

A symmetrical grouping is counterpointed by a profusion of blossoms and the inclusion of the top of a radiator, just visible above the table. Daylight from a window was enough to reveal form and texture and add a reflected highlight to the chair back.

Orchid leaves in a glass vase throw a double pattern of shadows onto the pale uniform background. To achieve this graphic effect, the photographer illuminated the subject with two tungsten lamps, one placed at each side of the camera. Before pressing the shutter release, he ensured that all surfaces were clean, using adhesive tape to remove fluff from the velvet-covered base.

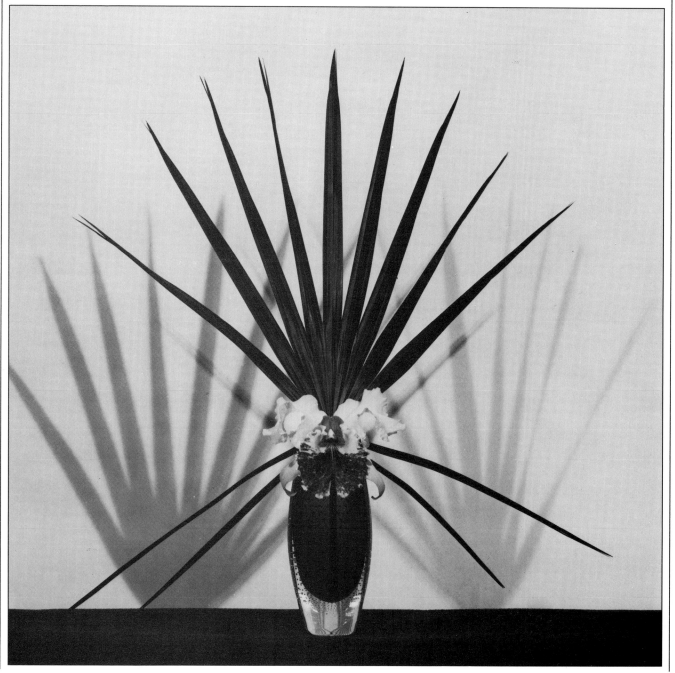

e nude/I

The slightly distanced, objective quality of black-and-white film makes it an especially good choice for nude photography. Portrayed in black-and-white, the human body with all its powerful emotional associations is simplified to a study in form or shape, line or texture.

Techniques of lighting, exposure and darkroom processing all offer ways to vary the extent of stylization or abstraction in a nude composition. The more you depart from conventional techniques, the less representational the image becomes. Some photographers take this to an extreme and produce images that puzzle the eye or suggest intriguing connections between human and nonhuman forms.

Plain backgrounds are best if you intend to treat the subject primarily as a study in line and tone, as in the photographs on these two pages. A dark background will tend to emphasize line by sharply defining the shape of a light-skinned body placed in front of it – and vice versa. But you need a fairly soft light on the figure to prevent flattening it or turning it into a pure silhouette. In the picture below, the light is soft enough to retain a subtle play of tone, and the photographer has exploited the film's grain to suggest the texture of sandstone.

Low-key effects, as in the striking picture of feet at right, are easier to achieve in monochrome than in color. Here, the photographer has used extremely limited light to create a mysterious image of a pair of dark-skinned feet. A soft lighting setup – with the main light source positioned fairly high and at an angle of 45 degrees in front of the model – revealed enough detail and contours to make the subject recognizable.

You can control skin tones by using filters as well as by manipulating the lighting. Green or blue filters make a figure appear suntanned, whereas yellow, orange or red make skin appear progressively paler. To take the effect still further, use infrared film for waxy, surreal tones.

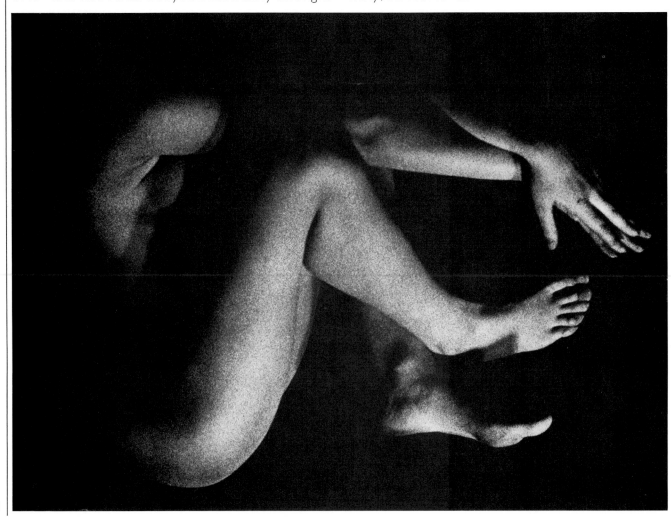

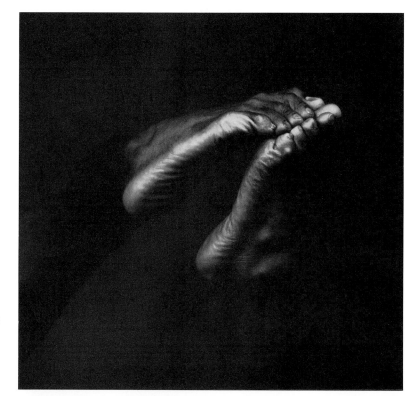

Feet *are rarely chosen as a photographic subject. The unusual composition by Robert Mapplethorpe at right makes use of bold framing and soft, angled lighting to reveal the varied textures, shapes and patterns in the pair of feet.*

The curving lines *of a curled-up body (left) are accentuated by the black backdrop and the contrasting angularity of the extended arm and fingers. By using fast (ISO 400) film pushed by one stop, the photographer imparted a pronounced grain to the nude.*

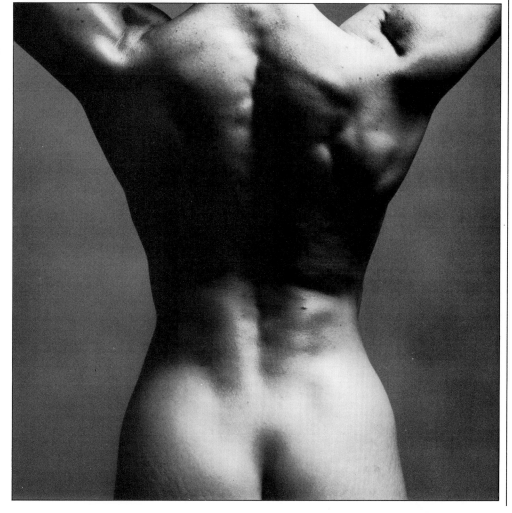

A muscular torso *(right) provides an original study of the female form. The centered pose and choice of lighting – overhead and to one side of the figure – help to emphasize the symmetry of line and to detail the rich tonal variations.*

The nude/2

Cropping the body closely within the picture's frame is one classic tradition in black-and-white nude photography. Another, in some ways more challenging, approach is to leave space around the figure and compose the image so that an interaction develops between the nude and a carefully chosen prop or setting.

Success with this approach depends largely on using the freedom inherent in black-and-white photography to depart from any kind of "real-life" situations. How you pose the model has more to do with theater or dance than with conventional portraiture. In black-and-white, studio nudes can have an impressive unity not only of tone but also of atmosphere, a sense of being outside time and place. Both photographers represented here capture this mood – one by setting up a surreal sequence, the other by using a massive, elaborate prop lifted out of its context.

The power and grace in the image of man and machine, below, depend on the positioning of the figure within the frame and the almost balletic pose with extended limbs and bent, averted head. For the ladder sequence, the photographer has used a technical trick to help move the situation further from reality – a skillful double exposure in the last two frames, which makes us feel that the whole series of images is part of a dream.

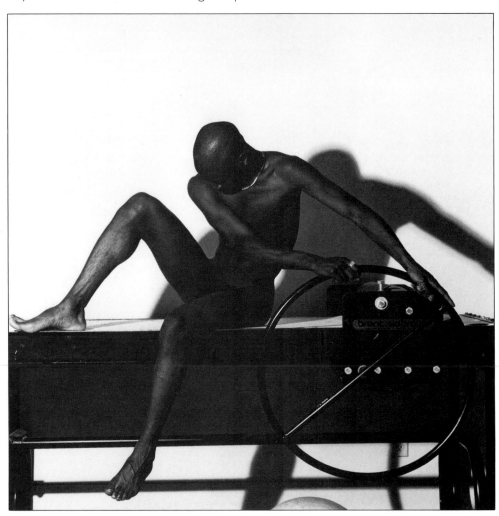

A male nude reclines on an etching press, his lithe body counterpointing the press's rigidity. A photolamp to the left of the camera caught the highlight of the man's silver chain and threw a shadow that echoes the theme.

In a bare room (opposite), a nude ascends a ladder and fades away before the ladder itself starts to dissolve. For each of the last two images, the photographer made two brief exposures on one frame.

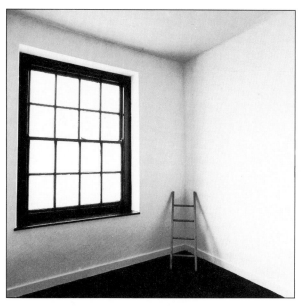
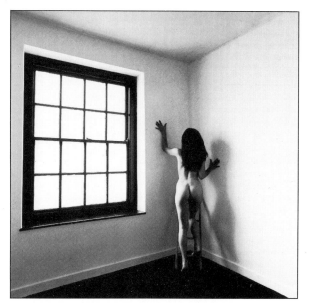
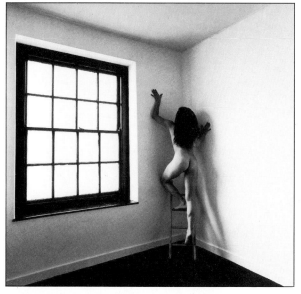
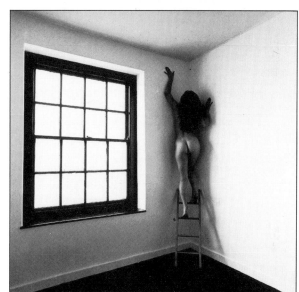
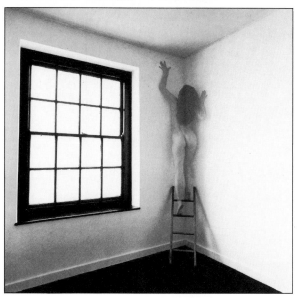
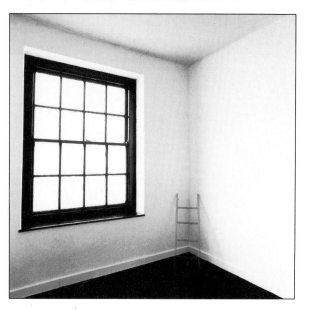

Reportage/1

Black-and-white film, the classic medium for photo-journalism, is well suited to the exacting deadlines of daily newspapers. A picture in black-and-white can be processed in minutes, wired to newspaper offices right across the world, and published on the front page the following morning.

Even when there are no deadlines to meet, black-and-white is usually the best choice whenever the aim is to get a message across in the strongest possible way. Colors often captivate the eye, glamorizing even the grimmest of subjects. When the emphasis is on human content, the simplifying directness of black-and-white is often appropriate, whether for revealing the horrors of war or disaster, or simply for documenting the realities of other people's ways of life. Black-and-white film also allows you to photograph people virtually anywhere, without worrying too much about back-ground; a picture such as the one below at left tends to have less impact in color, because the background details are too distracting.

Another advantage of black-and-white film is that it facilitates shortcuts in technique. Color temperature is irrelevant, so you are spared the need to think about corrective filtration. And by presetting the exposure controls and correcting errors at the darkroom stage, you give yourself more time to concentrate on an elusive subject – and on your own safety in a dangerous situation like the one below.

For action pictures and photography in low light, a good combination is an ISO 400 film, such as Kodak Tri-X Pan, with a fine-grain developer such as D-76. As well as allowing you the choice of a faster shutter speed or smaller aperture, a fast film gives you a broader exposure latitude and extends the effective length of a flash beam.

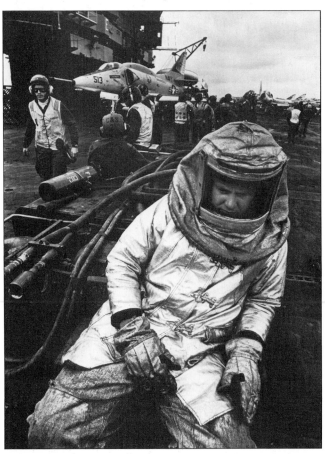

A rescuer in an asbestos suit prepares to retrieve pilots from a fire aboard an aircraft carrier. Fast film enabled the photographer to stop down for extensive depth of field, thus freeing him from the need for critical focusing.

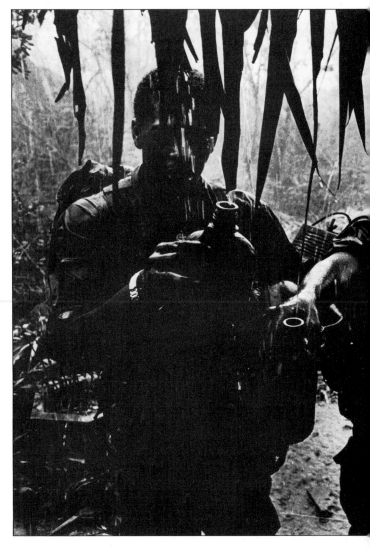

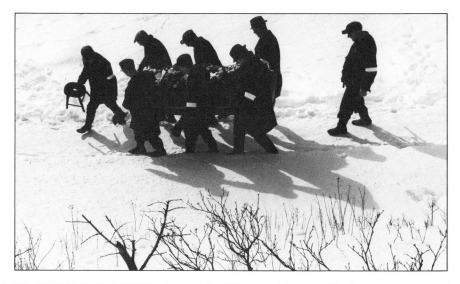

A funeral in Newfoundland retains a sense of solemnity that might have been compromised if color film had been used. Cropping during enlargement removed irrelevant details and improved compositional balance.

Overcrowding in West Belfast, Northern Ireland (below), is summed up in a wide-angle view that powerfully drives home the message. The photographer used a tripod-mounted camera in available light from a household bulb.

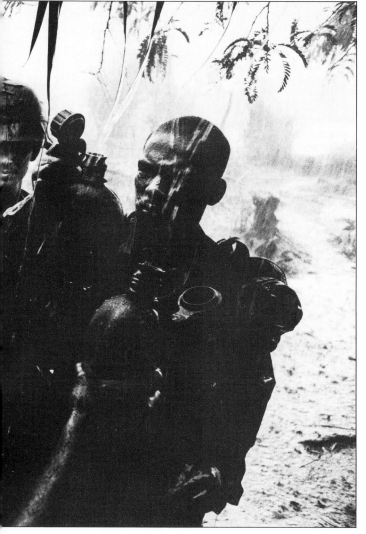

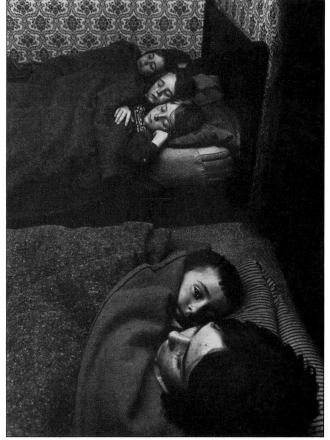

In driving rain (left), American GIs in Vietnam refill their water bottles. To cope with the dim light, the photographer push-processed his ISO 400 film, giving it 30 percent extra development time. This produced a graphic high-contrast image.

Reportage/2

Besides being valuable for covering fast-moving events under tight deadlines, black-and-white film can also be well-suited to a more relaxed, in-depth approach. For one thing, it is economical: long-term projects, such as documenting an urban or rural community over an extended period, inevitably consume a great deal of film and the relatively low cost of buying and processing black-and-white film makes it feasible to tackle projects that in color might be prohibitively expensive.

A photo-essay in black-and-white also tends to have a special coherence; the cool gray tones can link a long and disparate series of pictures in a way rarely possible with color. This makes it particularly important to introduce variety of viewpoint, scale, format and tonal values into a sequence, as in the photo-essay on Chicago shown here.

For every picture in a long-term project, use the same film, processing routine and printing paper. Resist the temptation to go straight from negative to print, or you will almost certainly pick images purely for their graphic qualities rather than for their human content. Instead, make a contact sheet. After choosing which images to print, file the contact sheet with the negatives for easy reference.

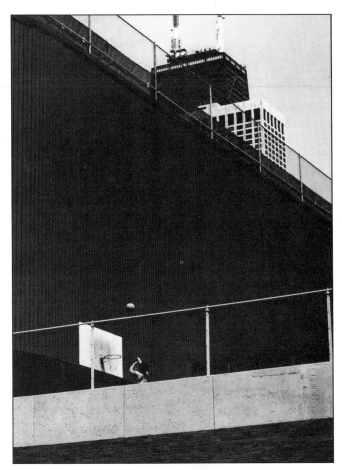

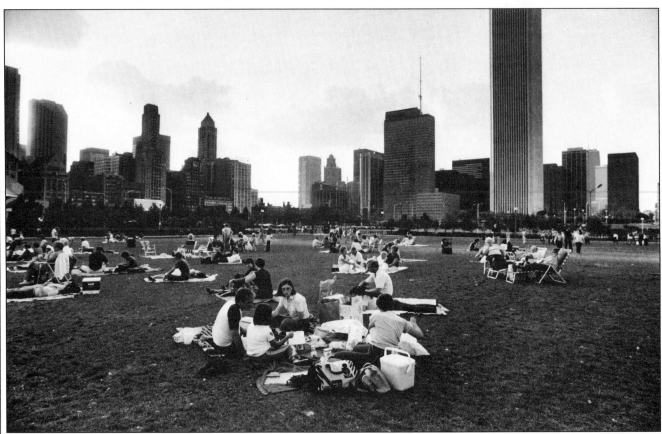

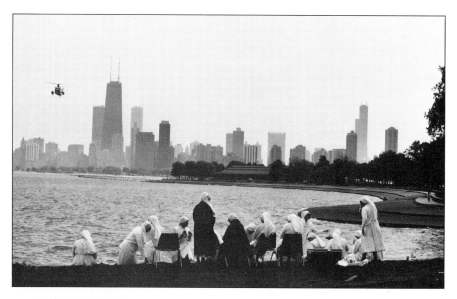

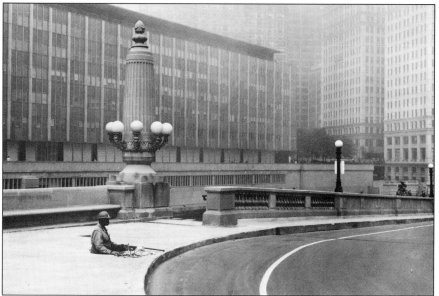

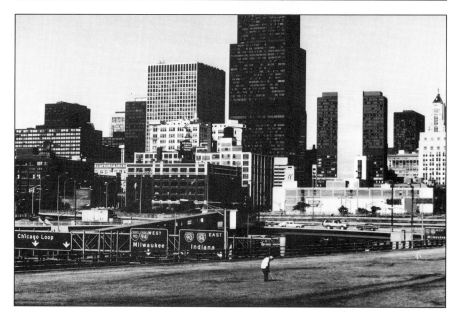

Chicago *was the subject of a series of pictures taken over 10 years by local photographer Fred Leavitt. The five images shown here are a selection from 87 published as an album. Avoiding obvious drama, Leavitt concentrated on the relationship between people and their densely built environment. In all the pictures here, the figures are dwarfed by their settings. This compositional unity was strengthened by the use of slow- and medium-speed film, which gave rich detail in each image. However, Leavitt ensured variety by using a range of lenses, from wide-angle (for example, for the picnic in Grant Park at the bottom of the opposite page) to powerful telephoto (for the golfer at left).*

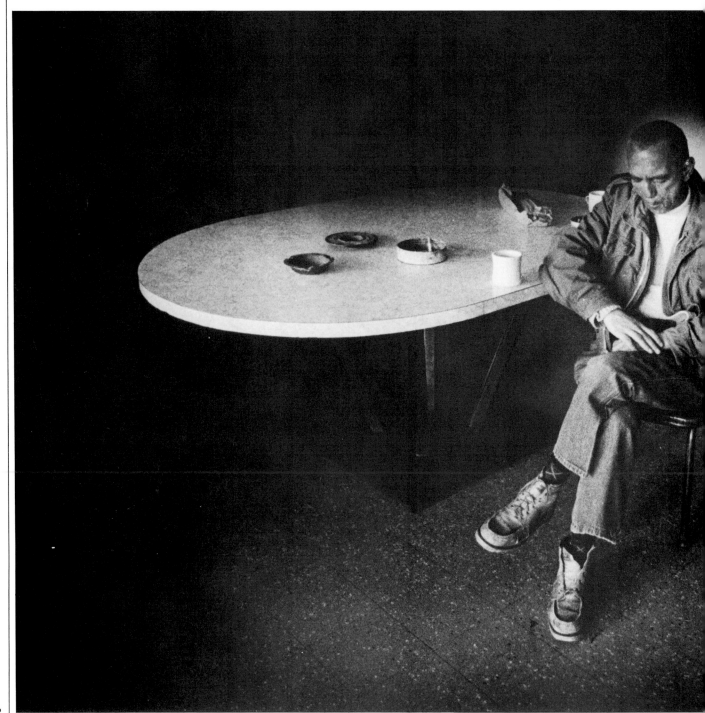

BLACK-AND-WHITE IN THE DARKROOM

In an age that places a premium on speed and convenience, processing and printing at home might seem like an anachronism. Yet to dismiss the hand-crafted print as outmoded and unnecessary is as misguided as to suggest to a fly fisherman that he could save himself trouble if he bought frozen fish from a store.

Far from being mundane, mechanical routines, black-and-white processing and printing are creative activities that allow the photographer to adjust and perfect the image seen in the camera's viewfinder. Even the simpler procedure of developing the film is by no means rigidly standardized: you can make adjustments to control tonal range and alter contrast to suit the subject or the lighting conditions. And at the printmaking stage, by applying techniques that are easily learned but always leave room for refinement, you can influence the final appearance of a picture to conjure up a memorable image like the one illustrated at left.

The following section of the book demonstrates how to use all the controls available in the darkroom to suit your individual artistic aims. It shows you how to create prints that are not just workmanlike copies of the subject but moody, evocative or dramatic images with a life of their own – a life that you have breathed into them.

A man lingering over coffee in an airport lounge acquires a strange intensity, thanks to skillful work in the darkroom. By burning in the bottom and side areas of the print, the photographer obliterated irrelevant details and created a metaphor for human isolation.

Processing control

To exploit the potential of black-and-white film to the fullest, it is worth taking extra care during development. This not only improves the final image quality, but also produces negatives you can print more quickly and efficiently.

The secret of obtaining perfect negatives is to be consistent at every stage of development rather than to follow a set of rules slavishly. Develop a processing procedure that suits you, then work at it until it becomes second nature. Such consistency ensures that every roll of negatives will have the same characteristics of density and contrast. The exact nature of these characteristics depends partly on your equipment and materials. For example, enlargers fitted with a condenser produce higher-contrast prints than do enlargers of the diffusion-box type, which are designed for producing color as well as black-and-white prints. Thus, a photographer who has a condenser enlarger may cut the contrast of his negatives slightly by shortening the development time that he allows.

Personal preference also plays a part. Some photographers prefer a dense negative with ample shadow detail, and therefore overexpose in the camera by setting a lower film speed on the ISO dial. Others prefer to give the minimum practical exposure, which makes negatives harder to print but keeps grain to a minimum and retains highlight detail. Only by experimenting can you tell which method is best for you. You will find such decisions easier to make if you keep a processing log like the one shown immediately below.

Film no.	Film type	Camera ISO setting	Subject/ Lighting	Developer used	Dilution	Time	Temp.	Contrast	Density	Notes

Keeping track

To make a processing log, rule off pages in a notebook into columns as shown above. After every picture-taking session, make a detailed entry in the log for each roll of film used. These notes will be invaluable for ensuring consistency and accuracy in the darkroom.

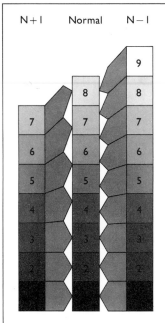

N+1 Normal N−1

The zone system in the darkroom

Following the principles of the zone system, as described on pages 42–5, you can control contrast in the darkroom with great accuracy. Normal development, or "N," suits a subject with normal contrast – that is, a span of eight or nine zones. Extending development by a specific time will expand the film's tonal range by one zone, so zone 7 becomes zone 8, as at left. This increased development time is designated N+1. With a very low-contrast subject you could increase development time further, to N+2, thus adding two zones to the tonal range of the print.

Reducing development works the other way around. If you place the deepest shadow in which you wish to hold detail in zone 2, and the brightest highlight falls in zone 9, you can be sure that the print will lack detail in this highlight. But by giving N−1 development you can place the brightest highlight in zone 8 and thus retain more detail.

The precise values for N and its increments depend on the film and developer and even the individual characteristics of your camera and enlarger. First you must experiment to find N. Then try cutting development by 30 percent for N−1 and increasing development by 50 percent for N+1.

Once you have standardized your processing routine, you can make controlled deviations from the norm to take special subjects or lighting conditions into account. Above all, you may wish to alter contrast. In brilliant sunlight a scene's deepest shadows may be more than eight stops darker than the brightest highlights; but in overcast conditions the tonal range is much narrower, nearer to five stops. Pictures taken in sunlight thus look very contrasty in a print, while those taken in dull weather might look too flat or gray. You can overcome these problems by printing on harder or softer paper, but a better solution is to anticipate low- or high-contrast negatives and then alter development accordingly to bring contrast to the desired level.

Extending development time makes the negative more dense overall but has a much greater effect on the heavily exposed areas – the highlights – than on areas that have had little exposure – the shadows. Thus, increasing development increases contrast, as in the example below. With reduced development, the reverse happens. Overall density is cut, but highlights are again more affected than shadows; contrast therefore decreases.

To apply these principles, keep track in your log of the weather conditions in which you expose each roll of film. As a starting point for experiments, try cutting development time by 25 to 35 percent for brilliantly sunlit subjects and increasing the time by 30 percent for overcast skies. When you plan to cut development, it is wise to overexpose by about half a stop to avoid losing shadow detail.

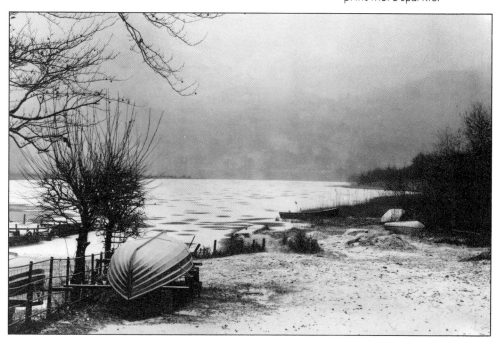

Extending development
The photographer made two exposures of this misty scene on ISO 400 film, one on the last frame of a roll and one on the first frame of a new roll. The first negative (far left) produced a print that was low in contrast (left). But increasing development by 30% for the second roll of film produced a more contrasty negative (below left) that yielded the print below. Higher contrast gave this print more sparkle.

Salvaging a negative

No matter how careful a photographer is during picture-taking or development, disasters occasionally happen, leading to a negative that is either too dense or too thin to make a reasonable print by normal means. Fortunately, however, such negatives can be at least partially rescued with intensifying or reducing solutions. The two examples on these pages show the improvements that both these formulas make possible. Whether reducing or intensifying, it makes sense to have a trial run first, using an unimportant negative.

Thin negatives are the result of underexposure or

underdevelopment, and they are difficult to print even on hard paper. Treating a thin negative with intensifier never produces a negative as good as one correctly exposed and processed in the first place, but at least it can add density and contrast. Ready-made intensifiers are available, but you can make your own, using the formula in the box opposite. Then proceed in room light, according to the step-by-step sequence of instructions below.

To thin overdense negatives – thus cutting down printing exposure – you can immerse them in "Farmer's reducer", which you can make following

Intensifying a negative

1 – Soak the film strip (or just one or two negatives) in water to which a few drops of wetting agent have been added.

2 – After mixing the intensifier in a tray, immerse the film strip and leave it in the solution until it looks pale brown.

3 – Remove the film strip with tongs and wash it under a stream of water until all the color of the intensifier has diasappeared.

4 – Redevelop the film strip in room light using print (not negative) developer. Fix and wash in the normal way.

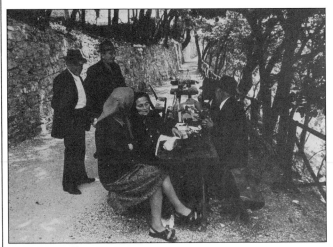

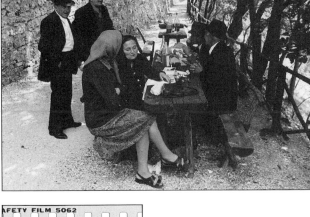

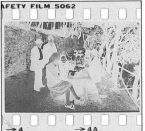

A thin negative
The underdeveloped negative at left produced a flat print (above) even on grade 5 paper. Intensification increased contrast and density (right) and yielded a superior print (above right).

instructions in the box at right. Then follow the step-by-step instructions given directly below. Simply remove the negative from the bath when you think that the density is almost correct and make a close examination; if necessary, you can return the negative to the bath for further treatment. The proportions in which you mix the two solutions, A and B, will affect the contrast of the reduced negatives. If you want to reduce contrast as well as density, use one part of A, 50 parts of B, 30 parts of water. Reduction will then take a little longer — from five to 10 minutes.

Intensifier		Reducer	
Solution A		Solution A	
Potassium		*Potassium	
bichromate	4 grams	ferricyanide	50 grams
Water	1 liter	Water	500 ml
Solution B		Solution B	
*Hydrochloric		Sodium	
acid	100 ml	thiosulfate	200 grams
Water	1 liter	Water to make	1 liter
To use, mix 10 parts A, 10 parts B and 5 parts water		To use, mix 1 part A, 50 parts B and 30 parts water	

Reducing a negative

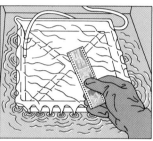

* Handle these chemicals with care, wearing rubber gloves. Potassium ferricyanide is extremely poisonous. When mixing the hydrochloric acid solution, always add acid to water, never water to acid.

1 – Soak the film strip or negative in a tray of water to which you have added a few drops of wetting agent beforehand.

2 – Mix the solutions in the required proportions, then immerse the film strip until it appears to have the desired density.

3 – Remove the film strip and examine it. If necessary, return the strip to the reducer. On completion, wash and dry the film.

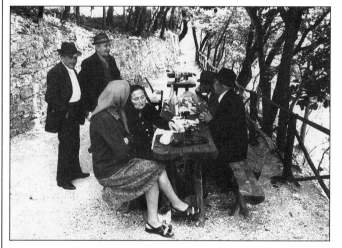

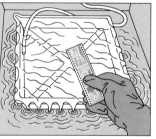

A dense negative
The overexposed negative at left produced a burned-out print (above), but by treating it with reducer the photographer was able to achieve a much better result (right and above right).

The contact sheet

A contact sheet is a convenient way to view every image on a roll of film at a glance. But it can also act as a practical reference, saving time and materials in the darkroom. Correctly made, a contact sheet lets you estimate printing exposure and assess which grade of paper is most suitable to print each image.

To use contact sheets in this way, you must standardize the procedure for making them, as diagrammed on the opposite page at top. Such consistency ensures that if variations do occur in your results, you can soon isolate a fault. But the method can be successful only if your camera exposures are equally consistent. Otherwise, as the strips immediately below illustrate, you will have to compensate by varying the printing exposure to obtain reasonable density in the images; if some on the same roll are too dark and others too light, you will be unable to derive any useful exposure information from the contact sheet at all.

However, if your contact sheet shows correctly exposed images, as in the strip on the opposite page, the sheet provides a starting point on which to base exposure for prints. If you made an 8 x 10-inch (20 x 25cm) sheet and the enlarger's beam neatly covered the paper, you should be able to pick any negative from the roll, place it in the enlarger and

Judging a contact sheet
The three strips at right show how density on a contact sheet can reveal information about exposure that may not always be clear from negatives. The shaded areas on the circle indicate the relative exposure time needed in printing, in order to obtain satisfactory density and contrast in the image. Inconsistent image densities (1) indicate some fault in the camera controls, exposure meter or your own exposure judgments. Very pale edges (2) indicate that the film was underexposed: the film speed dial was set too high. If the edges are so dark that they are not visible (3), the film was overexposed: you need to set the film speed dial higher.

1 – uneven exposure

2 – underexposure

3 – overexposure

make a reasonable 8 x 10-inch work print on the same grade of paper without changing the printing exposure time or enlarger settings.

Contrast is less easy to judge, but with practice and consistency in your contact sheet procedure, you will learn to assess the best paper grade for printing each negative. For example, if the images look flat and lifeless on the contact sheet, you will need to use a harder paper to increase contrast. On the other hand, if the contact proof images are harsh and contrasty, a softer grade of paper will help prevent the highlights from burning out and the shadows from printing inky black.

Making a contact sheet
The diagram at left represents the standardized procedure that should be followed whenever you print a contact sheet. Always set the enlarger head at the same height, making sure that the edges of the negative carrier are in focus on the baseboard. Always use the same aperture setting and exposure time. A good idea is to write these details on an adhesive label, then stick the label on the enlarger column at the correct height.

4 – correct exposure

An optimum contact sheet
A correctly exposed contact sheet (left) shows film edges just perceptibly paler than the borders, and images of consistent density. If the exposure and processing are correct and consistent, the same exposure time and enlarger settings can be used each time to produce a good-quality print like the one shown at right.

A work print

Before going to the trouble of creating a finely crafted print, it is worthwhile to make a quick proof print from the negative you have chosen. Decisions about contrast, paper grade, cropping and burning-in are difficult to make when looking at the tiny image on a contact sheet, and a moderately sized proof print makes such an evaluation much easier. When you are making very large exhibition prints, a proof is particularly valuable, because misjudgments can be very costly. A proof allows you to calculate exposure and dodging time, which you must scale up for larger print sizes, as explained in the box on the opposite page, above.

Make a straight print of the entire negative area, based on either a test strip or the exposure you gave the contact sheet. Do not crop the image at this stage; wait until you have the proof in front of you before making such decisions. And even if it is clear from the negative that the final print will need dodg-

ing or burning-in, resist the temptation to carry out such manipulations on the proof print. The attempt will complicate interpretation of the proof and is unlikely to be successful unless you are a very experienced printer.

Process the proof exactly as you would the final print, and wash and dry the proof before you draw any conclusions. Unless you plan to keep the proof for reference after making the finished print, a full wash is unnecessary; a minute in running water will do. However, it is essential to dry the print thoroughly before examining it closely, because black-and-white prints look somewhat darker when dry, as explained below.

From your proof print and from further test strips – if they prove necessary – you will be able to estimate the shading and burning-in that will be necessary, and also judge whether to use a different grade of paper (as described on the following pages).

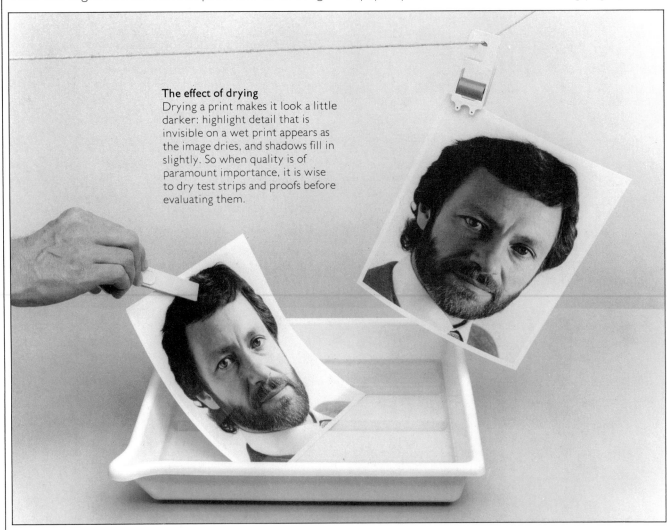

The effect of drying
Drying a print makes it look a little darker: highlight detail that is invisible on a wet print appears as the image dries, and shadows fill in slightly. So when quality is of paramount importance, it is wise to dry test strips and proofs before evaluating them.

Changing print size

The exposure needed to make a print is proportional to the picture's surface area. Thus, if you change print size, you can eliminate the need for new test strips by calculating the change in area mathematically. A pocket calculator facilitates this. First divide the new print size by the old one to get the change in width. Multiply this answer by itself – square it – to get the change in area. Finally multiply the original exposure time by the change in area to get the new exposure time. For example:

Old print width = 5 inches
Old exposure time = 4 seconds
New print width = 12 inches
New width ÷ old width = $12 \div 5 = 2.4$ (change in width)
$2.4 \times 2.4 = 5.76$ (change in area)
Change in area × original exposure = $5.76 \times 4 = 23.04$
New exposure time = 23 seconds

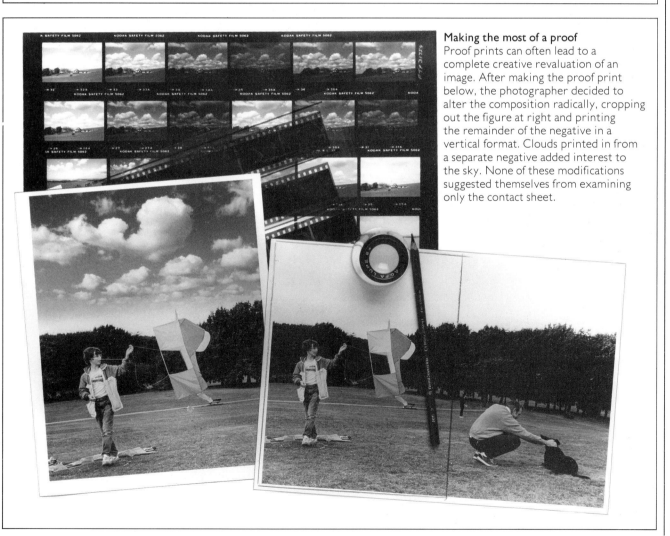

Making the most of a proof

Proof prints can often lead to a complete creative revaluation of an image. After making the proof print below, the photographer decided to alter the composition radically, cropping out the figure at right and printing the remainder of the negative in a vertical format. Clouds printed in from a separate negative added interest to the sky. None of these modifications suggested themselves from examining only the contact sheet.

The fine print/I

In principle, choosing the correct grade of paper is a simple matter. If your test print has black shadows and burned-out white highlights, you use a softer (lower contrast) grade of paper so that highlight and shadow details appear in the image. Conversely, printing onto harder (higher contrast) paper can expand the tonal range of gray-looking prints, yielding an image with greater impact.

In practice, though, following this simple procedure does not always lead to the most satisfactory print, particularly if a negative has a very wide range of tones, as the image below does. Soft, low-contrast paper will retain detail in both shadows and highlights but will make the midtones, which are usually the most crucial area of the image, appear muddy and dull. On the other hand harder paper makes the midtones crisp and attractive, but at the expense of shadows and highlights, which may appear featureless. To resolve this dilemma, choose

the harder paper and make a good proof that records the midtones exactly as you want them. You can then shade the shadows and burn in the highlights in order to restore detail to them.

When selecting a paper grade, do not feel obliged to use the paper's entire tonal range, from the deepest black the emulsion can record to a perfectly clean white. Some scenes, such as that shown below, do not in reality have a full range of tones from black to white. For example, on a misty day, the brightest highlight may be only four stops brighter than the deepest shadows, and this narrow tonal range should be reproduced on your print. Printing the view onto hard paper will certainly produce a photograph that has a solid black and clean white, but the image will look harsh and unreal. Instead, use a softer grade of paper and make a print whose tonal range extends from pure white to dark gray, as in the example below.

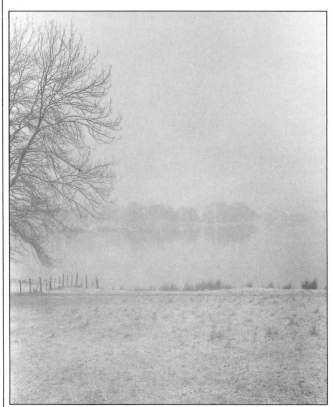 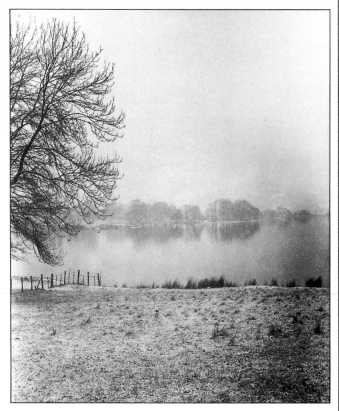

Hard vs. normal paper
A lakeside landscape with very low contrast appears with its tones accurately reproduced on normal paper (above left). A grade 4 paper created a brighter print (above right), with a clear white and solid black, but sacrificed the early morning atmosphere.

Soft vs. normal paper
Noon sun created high contrast in the scene above.
To control the tonal range, the photographer
printed on grade 0 (very soft) paper. The result
(above) holds detail in all areas but lacks sparkle.
Changing to grade 2 made a more interesting
print (below), and shadow detail was retained
by careful dodging.

The fine print/2

At the most basic level, dodging and burning-in are simple ways to retain detail and texture in areas of a picture that would otherwise appear too dark or light. But to think of these valuable printing controls just as corrective measures is to overlook much of their potential. As the pictures on these pages show, you can use dodging and burning-in to alter completely the appearance of the print, concealing unwanted detail in pools of darkness or light or subtly altering tonal values in order to emphasize different parts of the image.

With many negatives, you can use your hands or the straight edge of a piece of cardboard to control where the light from the enlarger falls. But not all pictures are neatly divided by straight lines into regions of dark and light tone. To dodge complex areas, you will need to cut a piece of cardboard into the same shape as the area to be dodged, but slightly smaller. The easiest way to do this is to lower the head of the enlarger so that the image on the baseboard is smaller than the print you are making. You can then trace the required profile onto black cardboard and use a sharp knife to cut out your dodger. Then when you hold the cardboard just above the surface of the print, the shadow will exactly match the size and shape of the area to be dodged.

Some negatives require quite complex burning-in and shading, and unless you keep notes of how you made the first print, you will have to repeat all your tests when you are ready to make more copies later. The simplest way to retain this information is to mark up a work print, as shown opposite. And if you have cut special dodging tools, these can be conveniently filed with the work prints.

The leader of an orchestra in rehearsal was surrounded by musicians with their instruments and by miscellaneous clutter, some of which appeared in the negative as shown by the proof print above. To conceal unwanted details and create a more striking portrait (right), the printer used basic burning-in techniques.

Keeping a record

Keeping a detailed record of how you first made a print can eliminate tedious testing later on. At far left, the photographer has recorded information on a tracing paper overlay. At the top of the print (circled) is the aperture. The other numbers denote the total exposure in seconds required by different areas of the picture. Along with this marked-up proof are stored dodging tools: for example, the almond shape was placed directly on the paper for a portion of the exposure to lighten the right eye.

An expressive portrait gains in impact, thanks to eight separate printing exposures (right). From the proof print above, which was underexposed by one stop, the printer determined the correct exposure for the face as 18 seconds at f/11. He first gave half this exposure with the eyes covered. Then he uncovered the eyes and gave another half exposure. Masking selected parts of the image with his hands and with dodging tools, he gave further exposures, culminating in a total of 54 seconds for the deep shadow at the left side of the face.

Fine-tuning contrast

Some negatives present problems that you cannot solve simply by changing paper grades or by dodging or burning-in during printing. For example, an outdoor scene might have two distinct areas, one of sunlight with occasional shadows, the other predominantly shaded. Printing on hard paper would produce a good image of the shaded part but would increase contrast in the rest of the picture to pure black and white. Soft paper, on the other hand, would render the sunlit area acceptable but make the shady part appear flat and dull by comparison.

One solution to such a problem is to print on variable-contrast paper like Kodak's Polycontrast or Polyfiber paper. These papers are coated with an emulsion that produces different contrast levels depending on the color of the light to which they are exposed. Yellow filtration in the enlarger lowers contrast, while magenta filtration increases it. To create a split-contrast picture such as the one opposite, you can use dodging techniques combined with a change in filtration, as explained below. With black-and-white enlargers, you use acetate filters in the enlarger's filter drawer; with some older enlargers, gelatin filters are fitted beneath the lens. With a color enlarger, you can make adjustments using the built-in filtration system.

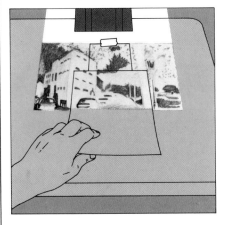

1 – Make a test strip on variable-contrast paper for the low-contrast area of the image, using high-contrast filtration. Gauge the correct exposure. Then follow the same method for the high-contrast area, using low-contrast filtration.

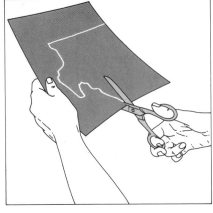

2 – Cut two dodging tools out of black cardboard, so that one matches the shape of the high-contrast area of the picture and the other the low-contrast area. If one tool is intended to cover the middle of the image, mount it on wire.

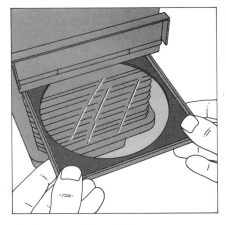

3 – Insert or dial in high-contrast filtration, depending on the type of enlarger you have. If you are using acetate filters and they are too large for your filter drawer, trim off any excess with scissors beforehand.

4 – Make an exposure onto a sheet of variable-contrast paper, using the time determined by the test strip for the low-contrast part of the image. While doing this, mask the low-contrast area with the appropriate dodging tool.

5 – Change the filtration in the enlarger from high to low contrast without switching on the room light or moving the printing paper from its position under the enlarging easel. Avoid jarring the enlarger.

6 – Make a second exposure, this time following the exposure time determined by the test strip for the high-contrast part of the image. While doing this, mask the low-contrast area that has already been exposed.

This street scene presented a problem of contrast. The photographer guessed that a print on grade 2 paper (bottom left) would produce acceptable contrast in the sunlit areas but would lack sparkle in the shadows, whereas a print on grade 5 paper (bottom right) would improve overall contrast but leave no tones in the sky. He therefore made two separate exposures on variable contrast paper, each with different filtration, as shown opposite. The resulting print (below) showed good contrast in all areas.

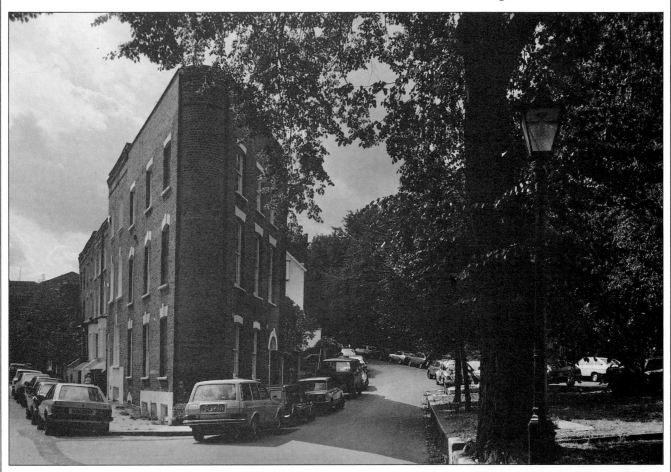

Problem negatives

Very high-contrast negatives are always difficult to print, because no matter which grade of paper you choose, it is difficult to retain detail in both highlights and shadows. However, there are two tricks that can help you deal with such problem negatives.

The simplest of these techniques involves nothing more complex than a dish of water. Sliding a half-developed print into the water as diagrammed below quickly arrests the development of the image's dark areas, since these soon exhaust the developer that has soaked into the paper. But pale areas exhaust the solutions more slowly, so highlights continue to appear long after development has stopped in the shadows. Thus, the overall contrast of the image diminishes.

If you use this procedure, always mix fresh developer and stop bath; there is a danger that exhausted developer will oxidize while the print is in the dish of water, causing brown stains. Fresh solutions reduce the risk of staining.

A different way to reduce contrast is to give the paper a very low-level overall exposure – a technique known as "flashing." This adds just enough extra density to make the picture's highlights darker, but not enough to make the whole print look fogged and gray. The diagrams on the opposite page explain how to test for the best exposure.

As shown here, the most convenient way to flash the paper is to set up a special low-power light source in the darkroom. But if you use the technique only occasionally, you can use the enlarger's light instead. Remove the negative from the carrier, and wind the enlarger head to the top of the column. Stop the lens down to its minimum aperture before flashing the paper. Alternatively, you can avoid the inconvenience of taking out the negative and moving the enlarger head if you diffuse the enlarger's beam. Do this by holding two styrofoam cups, one inside the other, so that they completely cover the enlarging lens.

Water-bath development

I – Make the printing exposure as usual, then immerse the sheet of paper in the developer. Agitate the tray of developer until the image just begins to appear on the paper.

2 – As soon as development has started, lift the print swiftly from the tray of developer, and transfer it to a tray containing tap water at the same temperature.

3 – Leave the print in the tray of water for about a minute. Do not rock the tray, as agitation will wash residual developer across the dark areas of the print, raising contrast.

4 – Transfer the print back to the developer and agitate for a few seconds. Then move the picture back into the water. Repeat the developer/water cycle until development is complete.

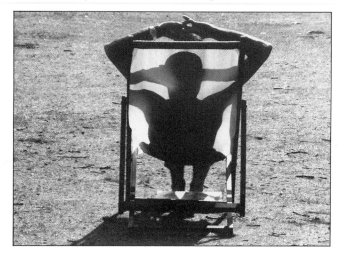

Water-bath treatment reduced contrast in the print at left, made from the negative shown on the opposite page, above. Detail has been retained in the shadow areas, recording as a dense black only in the very darkest parts of the image.

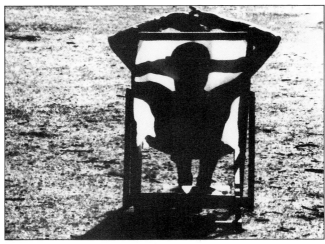

Reducing high contrast

The high-contrast negative above at left proved impossible to print in the normal way: a print on grade 2 paper (left) had good tonal separation in the shadows but white, burned-out highlights. However, the water-bath treatment described on the opposite page yielded a much better print, with more detail in all parts of the image (opposite, bottom). Flashing, as described in the sequence below, similarly improved the print quality (this page, bottom).

Flashing printing paper

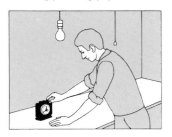

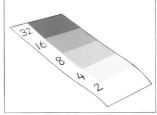

1 – Set up a 15-watt bulb at least three feet above the darkroom work surface, with a switch or timer within easy reach. With the light off, tear off a strip of printing paper for a test.

2 – Cover half the paper with cardboard, then turn on the light to fog the un-covered half of the strip for a series of test exposures – 1, 2, 4, 8, 16 and 32 seconds. Process normally.

3 – The best flashing exposure is the longest that produced no darkening of the paper – here, two seconds. If all steps darkened, test again, doubling the light-to-paper distance.

4 – Flash a whole sheet of paper for the time chosen, then print the negative normally onto this sheet. You may find it convenient to flash several sheets and store them in a box.

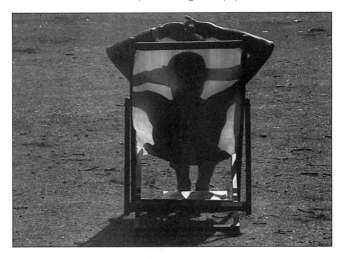

Flashing darkened the highlights in the print at left. The highlight areas show more detail than does the normally processed print at the top of this page. The reduced contrast makes this specially treated print more acceptable.

Processing for stability

Prints made on resin-coated paper and processed and stored according to manufacturers' instructions can last for decades without visible changes. However, you may sometimes want to extend the life of a black-and-white print: for example, if you want to sell a picture to a collector or a museum, or to make a portrait that can be handed down within your family from one generation to the next. To ensure maximum longevity for your pictures, you should print them on fiber-based paper and take a few extra precautions in processing.

First, always use a stop bath rather than a water rinse between the developer and fixer stages, and make sure that all three solutions are freshly mixed. Exhausted fixer can be particularly damaging to a print, leaving traces of harmful chemicals that no amount of washing can remove.

Make sure that you wash prints thoroughly. If the water falls below the recommended temperature, washing will be less effective unless you extend the time proportionately. The water should be replenished in approximately five-minute cycles: you can check this before you start processing by filling the washing tray with water, adding a vegetable dye,

then passing more water into the tray and timing how long it takes before the water runs clear again. Wash single-weight paper for half an hour, double-weight paper for a full hour. Never be tempted to guess wash times: always time them carefully with a clock.

After washing a print, it is advisable to check whether you have successfully removed residual chemicals. To do this, make up an estimator solution according to the Kodak formula given below and then follow the sequence of step-by-step instructions. You can apply the estimator solution either to a small piece cut off the edge of the print, or to an unexposed piece of the same type of paper processed and washed at the same time.

To extend the life of an image still further, you can tone the print in gold or selenium protective solution, as the photographer did for the picture opposite; these solutions do not affect the image color.

Remember too that storage and viewing conditions are as important as correct processing. A print stored in a cool, dark, dry place, free from atmospheric pollution, will last much longer than a picture displayed in direct sunlight in a humid room.

Testing for residual chemicals

After processing and washing a fiber-based print, you can test it for residual chemicals (hypo) by applying a hypo estimator solution, as described in the step-by-step instructions below. Make up the solution according to the formula at right. It will keep for about six months if stored in a brown bottle with a screw top or glass stopper away from strong light at a temperature of 65° to 75°F (18° to 24°C).

Hypo estimator	
Water	750 milliliters
Acetic acid (28% solution)	125 milliliters
Silver nitrate (crystals)	7.5 grams
Water to make	1 liter

Wear rubber gloves when handling the chemicals. Note that acetic acid is corrosive at strengths above 25%. Do not allow the made-up solution to come into contact with hands, clothing, negatives, prints or undeveloped photographic material, or it will cause a black stain.

1 – Wash the print thoroughly, making sure that the water flows evenly around the paper. The water should be no cooler than 65°F (18°C). Wipe surface water from the print, using a soft sponge.

2 – Cut a small piece from the margin of the print. Place one drop of hypo estimator on the surface of this piece, allow to stand for two minutes, then rinse with water to remove excess.

3 – Compare the stain produced with the ranges of tints on a special estimator chart available from Kodak. This gives a measure of the residual chemicals. If necessary, wash the print again.

The British ice dancers Jayne
Torville and Christopher Deane skate
their way to a gold medal at the 1984
Winter Olympics in Yugoslavia. To
produce a stable image that would last,
the print was treated with gold toner.

Enhancing grain

Photographers usually go to considerable lengths to keep grain in their prints to a minimum, to be sure of retaining maximum image detail. However, there are some situations where grain is desirable for adding mood to a print or creating a more abstract effect, as in the striking photograph printed on the opposite page.

To produce a print with enhanced grain, there are various steps you can take right from the beginning of the picture-taking process. Use a 35 mm camera in preference to a larger format, and load a fast film such as Kodak's Recording Film 2475. Set the film speed dial to half the nominal value of the film, which will create an overexposed image. Then, using a wide-angle lens, compose the subject so that it occupies only the central area of the viewfinder. This will enable you to make a greater enlargement, and thus achieve a grainier image.

After exposure, develop the film for twice the normal time, and then reduce the density of the negative with Farmer's reducer (as described on pages 80-81). When making the print, use a condenser enlarger if possible. Avoid a glassless negative carrier: between two sheets of glass the negative will remain absolutely flat, preventing the grain from wandering in and out of focus across the area of the frame. Printing onto hard, glossy paper gives the grainiest results.

50 mm lens

Increasing grain by enlargement
The photographer who took the rural scene at left, using a 35 mm camera fitted with a normal lens and loaded with ISO 400 film, realized that the image might benefit in mood from a coarser grain. So, for the next frame, without changing his position, he switched to a 28 mm lens. After processing, he made a selective enlargement of just the center area of this picture to obtain the atmospheric image below. (The total area covered by the negative is shown below at left.)

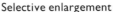

28 mm lens

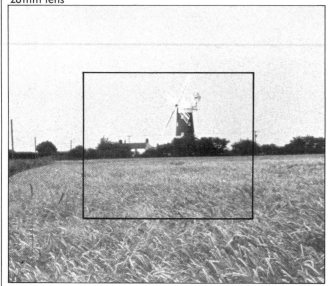

Selective enlargement

Grain-enhancing developer

If you are prepared to mix your own chemicals, you can enlarge the grain of your prints using a developer made up according to the formula at right.

First, heat the water to approximately 90°F (32°C). Dissolve one part sodium carbonate in four parts hot water. Add the rest of the chemicals and dissolve them in about half the amount of water remaining. Then add the rest of the water. Use the developer within six hours. Complete processing in the normal way.

Metol	0.5 gram
Glycin	0.5 gram
Anhydrous sodium sulfite	4 grams
Anhydrous sodium carbonate	50 grams
Potassium bromide	0.5 gram
Water to make	I liter

When handling these chemicals, wear rubber gloves and avoid skin contact.

A regiment of vines on a crest in a rolling, frost-covered landscape (below) makes a dynamic image with an abstract quality that is emphasized by the coarseness of the grain. Using a fast film, the photographer enhanced the graininess by overexposing by one stop, by doubling development time and then treating the negative with a reducer.

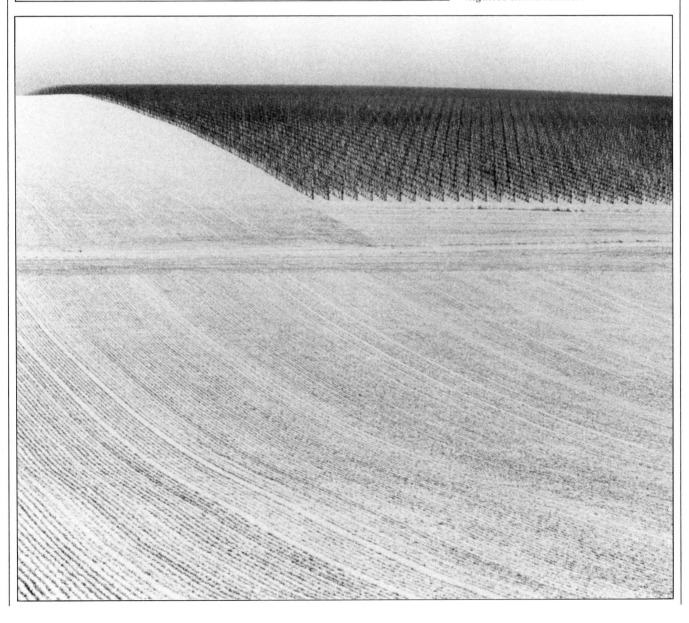

Gum bichromate prints

By making your own printing paper using the gum bichromate process, you can print from negatives to create unusual images like the one opposite. This 19th-Century method is enjoying a revival, largely because the procedure is very simple and allows you to use pigments of virtually any color.

Gum bichromate printing involves mixing gum arabic and potassium dichromate to make a light-sensitive coating on paper, which becomes insoluble on exposure. (Avoid skin contact when handling the chemicals.) The paper registers an image when held in contact with a negative and exposed to an ultra-violet light source, such as a sunlamp. As a starting point, you need a large negative – either taken on sheet film or made by enlarging a small negative onto duplicating film. Exposure time depends on the wattage of the lamp and its distance from the contact frame. Test these variables first to assess the exposure required. Follow the sequence below for both the tests and the final print. Develop immediately by washing away the soluble gum in the highlight areas (step 8), taking care not to touch the emulsion. Development may take several hours, but you can speed it up by agitating the print with a soft brush or water spray. When the image has formed, dry the print on blotting paper or hang it up to dry.

Preparing the chemicals

1 – Size the paper in a mix made from a 10 percent solution of gelatin in a liter of hot water. Leave the paper in the mix for at least five minutes, then smooth off the excess and hang the paper to dry.

2 – Wearing rubber gloves, mix a 10 percent solution of potassium dichromate by adding 15g of potassium dichromate crystals to 150ml warm water. Store the mixture in a dark place, as it loses its strength in daylight.

3 – Make up a gum arabic solution by adding 140g of powdered gum arabic to 285ml of warm water. The gum may take some hours to dissolve, but home mixing will produce a richer print than premixed gum arabic.

4 – Mix the two solutions in the ratio of three parts gum arabic to one part potassium dichromate. Then add the pigment of your chosen color. Use one part color to four parts emulsion. Stir the mix thoroughly.

Coating the paper and making the print

5 – Pour a little of the gum mixture onto the sheet of paper that has been sized (step 1). Work away from direct sunlight. Do not be deterred if the color looks wrong: it will adjust after processing.

6 – Coat the mixture evenly and fairly thinly over the paper. A latex foam roller is quick to use and gives a smooth finish. Use a brush if you want more texture. Allow the coating to dry in a dark place.

7 – When the coating is dry, position a negative on the paper, emulsion to emulsion. Tape it down and cover with glass. Expose the image, judging the time according to the strength and distance of the UV light source.

8 – To develop the image, wash the print in warm water, then leave to soak. After about 10 minutes, the unexposed areas will start to wash clear. Brush or spray the print as it soaks until the full tonal range appears.

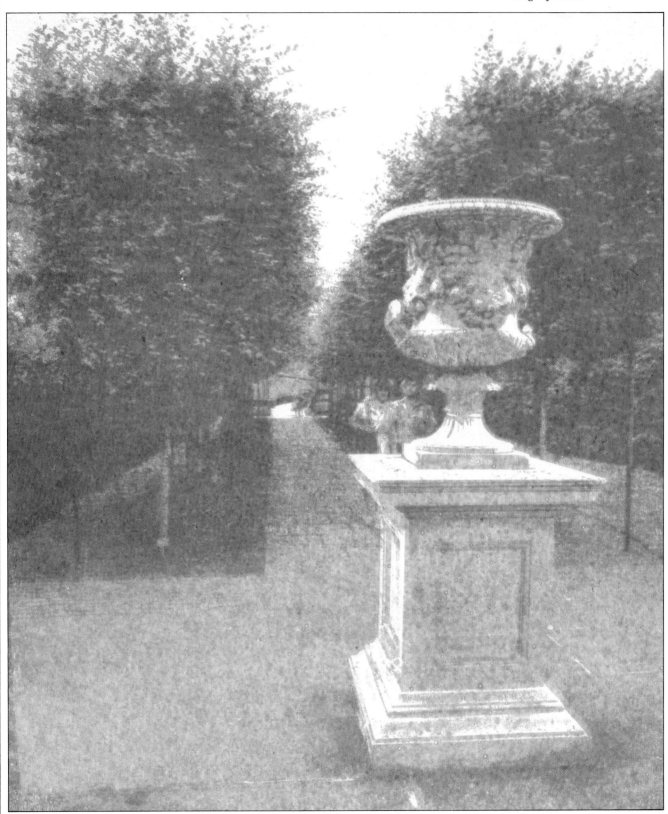

An urn on a plinth
dominates a view of formal
gardens. The gum bichromate
process gave this print
its softness and limited
range of tones.

Glossary

Albumen print
A print made on thin paper coated with a layer of salted egg white to yield a glossy surface. Albumen prints were common in the second half of the 19th Century. They were often toned with a gold solution to improve color and stability.

Ambrotype
An early photographic image resembling a daguerreotype, for which it was a less expensive substitute. A collodion negative was treated with a mercury compound and viewed against a black background to create a positive image. See COLLODION PROCESS

Available light
The existing light (natural or artificial) in any situation, without the introduction of supplementary light (for example, flash) by the photographer. The term usually refers to low light levels, for example indoors or at dusk.

Backlighting
A form of lighting where the principal light source shines toward the camera and lights the subject from behind. Because contrast tends to be high, judgment of exposure can be difficult in back-lit scenes. An average exposure meter reading over the whole scene will often produce over- or underexposure, so it is advisable to take a separate reading for the part of the subject for which the normal exposure is required. As well as causing problems, backlighting can also be used creatively to give, for example, pure silhouetted shapes or a halo effect around a sitter's head in portraiture.

Bleach
A chemical bath to convert the black metallic silver that forms a photographic image into a compound such as silver halide, which can then be dissolved or dyed. Bleach is used in toning and in many color processes.

Bottom lighting
A form of lighting in which the principal light source shines from directly below the subject.

Bracketing
A way to ensure accurate exposure by taking several pictures of the same subject at slightly different exposure settings above and below (that is, bracketing) the presumed correct setting.

Burning-in (printing-in)
A technique used in printing photographs whereby selected areas of an image are given more exposure than the rest.

Other areas are shaded from the light during this process.

Calotype
A photographic process invented by W.H. Fox Talbot in 1840, yielding images on writing paper that had been soaked in a salt solution and sensitized with silver nitrate.

Collodion process
The first practical process for producing negatives on glass, invented by F. Scott Archer in the mid-19th Century. A glass sheet was coated with collodion (guncotton dissolved in alcohol and ether) and sensitized with silver nitrate; this sheet was then exposed in a camera and developed. Because the plate became insensitive if allowed to dry, the collodion process was also known as the "wet-plate" process.

Combination printing
A general term describing a number of photographic techniques in which more than one negative or transparency are printed onto one sheet of printing paper to make a composite image.

Contact sheet
A sheet of negative-sized photographs made simply by placing the printing paper in direct contact with the negatives during exposure.

Contrast
The difference in brightness between the lightest and darkest parts of a photographic subject, negative, print or slide. Contrast is affected by the subject brightness, lighting, film type, degree of development, the grade and surface of the printing paper, and the type of enlarger used.

Cropping
Trimming or masking an image along one or more of its edges to eliminate unwanted parts.

Daguerreotype
A 19th-Century photograph (usually a portrait) consisting of a positive image formed by mercury vapor on a polished silver-coated plate. To view the image, it was necessary to hold up a black surface to avoid reflections from the shiny parts of the plate; these formed the shadow areas. The process was invented by Louis Daguerre in France in 1839, and was the first to be a commercial success.

Developer
A solution containing a number of chemicals that will convert a latent image on an exposed photographic material to a visible image.

Developing tank
A lighttight container, made of plastic or steel, in which film is developed. The exposed film is loaded into the tank in complete darkness and temperature-controlled chemicals are added at precisely timed intervals to make the image visible and stable.

Diffused light
Light that has lost some of its intensity by being reflected or by passing through a translucent material, such as tracing paper. Diffusion softens the light by scattering its rays, eliminating glare and harsh shadows, and is therefore of special value in portraiture.

Dodging (shading)
Means of reducing exposure in selected areas during printing by holding a solid object between the lens and the light-sensitive paper. By moving the object, abrupt changes in tone can be avoided.

Dry plate
A gelatin-coated photographic plate introduced in the late 19th Century. Unlike wet plates, dry plates did not have to be sensitized by the photographer but were available already coated.

Drying marks
Blemishes on a photographic image caused by uneven drying. Such marks can be prevented by adding a wetting agent to the final rinse or by evenly sponging all the droplets of water off the surface.

Emulsion
The light-sensitive layer of film or printing paper. Conventional photographic emulsion consists of very fine silver halide crystals suspended in gelatin, . which blacken when exposed to light.

Enlarger
An apparatus that makes enlarged prints by projecting and focusing an image from a negative or transparency onto light-sensitive paper, which must then be processed to reveal the final print.

Enlarger head
The part of the enlarger that contains the light source, the negative carrier and the lens. An enlarger head also houses a filter drawer or built-in filtration system.

Enlarging easel (masking frame)
A board used with an enlarger for positioning printing paper and keeping it flat and still during exposure.

Exposure
The amount of light that passes through a lens (in either a camera or an enlarger) onto a light-sensitive material (film or photographic paper) to form an image.

Too much light causes overexposure: this makes negative film look too dark and reversal film look too light. Underexposure (too little light) has the reverse effect. In enlarging, overexposure makes a print from a negative too dark and a print from a slide too light. Underexposure has the reverse effect.

Exposure latitude

The ability of a film to record an image satisfactorily if exposure is not exactly correct. Black-and-white and color print films have more latitude than color transparency films, and fast films have greater latitude than slow ones.

Exposure meter

An instrument for measuring the intensity of light so as to determine the shutter and aperture settings necessary to obtain correct exposure. Exposure meters may be built into the camera or be completely separate units. Separate meters may be able to measure the light falling on the subject (incident reading) as well as the light reflected by it (reflected reading); built-in meters measure only reflected light. Both types of meter may be capable of measuring light from a particular part of the subject (spot metering) as well as taking an overall reading.

Farmer's reducer

Solution of potassium ferricyanide and sodium thiosulfate, used to bleach negatives and prints. It is named after the English photographer E.H. Farmer, who invented it in 1883.

Fiber-based paper see PHOTOGRAPHIC PAPER

Fill-in light

Additional lighting used to supplement the principal light source and brighten shadow. Fill-in light can be supplied by redirecting light with a white cardboard reflector, as well as by supplementary lamps or flash units.

Film speed

A film's sensitivity to light, rated numerically so that it can be matched to the camera's exposure controls. The two most commonly used scales, ASA (American Standards Association) and DIN (Deutsche Industrie Norm), are now superseded by the system known as ISO (International Standards Organization). ASA 100 (21° DIN) is expressed as ISO 100/21° or simply ISO 100. A high numerical rating (400 ISO and over) denotes a fast film – one that is highly sensitive to light and therefore ideal in poor lighting conditions.

Filter

A translucent material, such as glass, acetate or gelatin, used with a camera or enlarger to modify the light passing through the lens and thus control the appearance of the image. Color filters over the camera lens are often used with black-and-white film to alter the relationships between different tones that occur within an image.

Fixer

A chemical bath used to make a photographic image stable after it has been developed. The fixer stabilizes the emulsion by converting the undeveloped silver halides into water-soluble compounds, which can then be dissolved away.

Flashing

Reducing contrast during printing by giving the printing paper a brief additional overall exposure.

F-numbers

Numbers on a camera's or enlarger's lens barrel, indicating a scale of aperture settings. Each setting progressively doubles or halves the amount of light reaching the film or paper.

Fogging

A veil of silver in a negative or print that is not part of the photographic image. Fogging can be caused by light entering the camera, film cassette or darkroom and partially exposing the film or paper, by faulty processing solutions such as an overactive developer or a weak fixer, or by improper storage of the unexposed material.

Frontlighting

A form of lighting in which the principal light source shines from the direction of the camera toward the subject.

Gelatin

A substance used as the binding agent for the grains of silver halide in photographic emulsions. Gelatin, which is also used to make filters, is an animal protein, for which completely satisfactory synthetic alternatives have not been devised. The properties that make it especially suitable for use in emulsions are transparency, flexibility, permeability by the solutions used in processing, the ease with which it can be converted from liquid to solid, and its protective bonding action toward silver halide grains.

Graduate

A calibrated glass, plastic or steel container used for measuring liquids, for example, photographic processing chemicals, by volume.

Grain

The granular texture appearing to some degree in all processed photographic materials. In black-and-white photographs the grains are minute particles of black metallic silver that constitute the dark areas. The more sensitive – or fast – the film, the coarser the grain will be.

Gum bichromate print

A print with an image that is formed on a coating of sensitized gum to which pigment has been added. Exposure to light makes the gum insoluble; thus, washing the exposed image with water dissolves away the highlights while leaving the pigmented shadow areas intact.

Hard light

Strong, direct light that has not been diffused in any way. Hard light produces sharp, dense shadows and creates distinct modeling of forms.

High key see KEY

Highlights

Bright parts of a subject that appear as the darkest areas on a negative and as the lightest areas in a print.

Hypo eliminator

A solution used to remove traces of residual fixer from a print. ("Hypo" is a colloquial term for sodium thiosulfate, which until recently was used universally as a fixer.)

Key

A term describing the prevailing tone of a photograph. "High-key" refers to a predominantely light image; "low-key" refers to a predominantely dark one.

Large-format camera

A term applied to cameras producing large images – negatives or transparencies 4 × 5 inches or larger. Large-format cameras are very simple in construction. A front panel holds a lens, shutter and iris diaphragm; a bellows links this front panel to the rear panel, which contains a ground glass screen used for focusing. Focusing is accomplished by moving front and rear panels closer together or farther apart. Immediately before exposure, the photographer replaces the ground-glass screen with a sheet of film. A special box-shaped holder protects the sheet of film from light until the film is inside the camera.

Latitude see EXPOSURE LATITUDE

Low key see KEY

Masking

The act of blocking light from selected areas of an image for various purposes – for example, to cover the edges of a piece

of printing paper during exposure in order to produce white borders.

Masking frame see ENLARGING EASEL

Negative
A developed photographic image in which light tones are recorded as dark and dark tones as light. Usually, a negative is made up on a transparent base so that light can be beamed through it onto light-sensitive printing paper to form a positive image.

Negative carrier
A device that holds a negative or transparency flat in an enlarger between the light source and the lens.

Panchromatic
A term applied to sensitized materials (especially black-and-white film) that respond to all the visible colors of the spectrum and to some wavelengths of ultraviolet radiation.

Photographic paper (printing paper)
Paper with a light-sensitive emulsion, used for making photographic prints. When a negative or slide is projected onto printing paper a latent image forms, and this is revealed by processing. Printing paper may be fiber-based or resin-coated (RC): resin-coated papers offer speedier processing because they are water-repellent. Papers come in grades according to their contrast range.

Photolamp
A tungsten light bulb specially designed for photographic use. Photolamps are similar to household bulbs, but bigger and brighter.

Platinum print
A print made on special paper containing light-sensitive iron salts and a platinum compound, but no silver. Such prints are characterized by rich black tones.

Positive
A photographic image that corresponds in tonal values to the original subject.

Primary additive colors
Blue, green and red. Lights of these colors can be mixed together to produce white light or light of any other color.

Print
A photographic image produced by the action of light (usually passed through a negative or transparency) on paper coated with a light-sensitive emulsion.

Printing-in see BURNING-IN

Printing-out paper
An early type of printing paper that darkened to form an image under the action of daylight, as opposed to being exposed briefly under a negative and subsequently developed.

Printing paper see PHOTOGRAPHIC PAPER

Processing
The sequence of activities (usually developing, stopping, fixing, washing and drying) that will convert a latent image on film or photographic paper into a visible, stable image.

Push-processing
Increasing development time or temperature during processing, usually to compensate for underexposure in the camera or to increase contrast. Push-processing is often used after uprating the film to cope with dim lighting. See UPRATING

Reel
The inner core of a developing tank, used to hold film in a spiral to prevent one layer of film from touching another during processing. Some reels are adjustable to fit different film formats.

Reflector
Any surface capable of reflecting light, but in photography generally understood to mean sheets of white, gray or silvered cardboard employed to reflect light into shadow areas. Lamp reflectors are generally dish-shaped mirrors, the lamp recessed into the concave interior, which points toward the subject. Studio electronic flash equipment is often combined with an umbrella reflector, usually silvered, mounted on a stand.

Resin-coated (RC) paper see PHOTOGRAPHIC PAPER

Rimlighting
A form of lighting in which the subject appears outlined with light against dark background. Usually, the light source in rimlit pictures is above and behind the subject, but rimlit photographs can look quite different from conventional backlit images, in which the background is usually bright.

Shading see DODGING

Shadows
Dark parts of a subject that appear as the lightest areas on a negative and as the darkest areas in a print.

Sidelighting
A form of lighting in which light falls on the subject from one side. Sidelighting produces dramatic lighting effects, casting long shadows and emphasizing texture and form.

Silver halide
A light-sensitive compound of silver with a halogen such as bromine, chlorine or iodine. Silver halides are the main constituents in photographic emulsion. The latent image produced in these halides by the action of light is converted to metallic silver by developers.

Soft light
Light that has lost its intensity by being diffused or reflected. Soft light produces weak shadows and reveals fine detail and textures.

Spotting
Retouching a print or negative to remove spots and blemishes.

Stop bath
A weak acidic solution used in processing as an intermediate bath between the developer and the fixer. The stop bath halts development and at the same time neutralizes the alkaline developer, thus preventing it from lowering the acidity of the fixer.

Test-strip (exposure test)
A strip of printing paper that is given a range of exposures or filtrations across its length as a test for the correct image density.

Tintype (ferrotype)
A photograph made on a wet collodion emulsion coated on black enameled tinplate. Tintypes were often made by itinerant photographers in the late 19th and early 20th Centuries.

Tungsten light
A common type of electric light for both household and photographic purposes, named after the filament of the metal tungsten through which the current passes.

Uprating
Setting a film speed on the camera higher than that at which the film was designed to be used. Effectively, this means underexposing to cope with dim light: an appropriate compensation is then made for the underexposure by increasing, or "pushing", the development time.

Variable-contrast paper
Black-and-white photographic paper that has variable contrast. Adding yellow filtration to the enlarger filter pack reduces the contrast of the print, and adding magenta filtration increases the contrast.

View camera see LARGE-FORMAT CAMERA

Wet plate see COLLODION PROCESS

Zone system
An advanced method of relating exposure readings to tonal values in picture-taking or printing, devised by American photographer Ansel Adams.

Index

Acknowledgments

Picture Credits
Abbreviations used are: t top; c center; b bottom; l left; r right.

Cover Romano Cagnoni

Title William Meyer/Click/Chicago. **7** John Goldblatt. **8** Robin Laurance.
9 John Foley. **10-11** Ken Griffiths. **12** Robin Laurance. **13** Martine
Franck/The John Hillelson Agency. **14-15** John Foley. **16-17** James
Robertson/The John Hillelson Agency. **18** G. Bierry, Musée Nicéphore
Niepce. **19** J.N. Niepce/Kodak Museum. **20** t Kodak Museum, b
Daguerre/Société Francaise de Photographie. **21** All Kodak Museum. **22**
l courtesy of Fox Talbot Museum. **22/3** c Kodak Museum. **23** t courtesy
of Laycock Abbey Collection/Fox Talbot Museum, b Victoria and Albert
Museum. **24** t Julia Margaret Cameron/Kodak Museum, b John Thom-
son/The John Hillelson Agency, br Kodak Museum. **25** t J. Robertson/
Kodak Museum, b John Thomson/The John Hillelson Agency. **24-25** All
pictures with the kind permission of the Victoria and Albert Museum.
28 l Annie W. Brigman/Kodak Museum. **28-9** c Horace W. Nicholls/
Kodak Museum. **29** tr International Museum of Photography at George
Eastman House. **30** tl Fox Talbot, bl Julia Margaret Cameron. **30-31** c
Olive Edis, tr P.H. Emerson, bl René Le Bègue, all with the courtesy
of Michael Wilson. **32-33** All Kodak Museum. **34-35** Jane Bown. **36** l John
Benton-Harris. **36-37** c Paul Yule. **37** t John de Visser. **38** l Paul Yule.
38-39 Janine Wiedel. **40-41** Paul Yule. **42-45** James Ravilious. **46** tl
Richard Cooke, **46** bl Mike Newton, **46** c William Meyer/Click/Chicago.
47 r John de Visser. **48-49** Ansel Adams. **50-51** tl and b Nick Meers. **54-55**
John Foley. **56-57** James Ravilious, **57** t Robin Laurance, b John Garrett.
59 Glynn Satterley. **60** Robert Mapplethorpe. **61** Geray Sweeney. **62** t
Nels. **63** Barry Lewis/Network. **64-65** Erich Hartmann/Magnum/The
John Hillelson Agency. **66** Gene Nocon. **67** Robert Mapplethorpe. **68**
Jean-Louis Michel/Fotogram. **69** Robert Mapplethorpe. **70** Robert
Mapplethorpe. **71** Carole Segal. **72** l and c Philip Jones Griffiths/
Magnum/The John Hillelson Agency. **73** t John de Visser, br Chris Steele-
Perkins/Magnum/The John Hillelson Agency. **74-75** All Fred Leavitt/
Click/Chicago. **76-77** William Meyer/Click/Chicago. **80-81** Mike
Newton. **86-87** all Tim Stephens. **88** George Taylor. **89** Alastair Thain.
91 John Goldblatt. **92-93** Brian Westbury. **95** Eamonn McCabe. **97** b
Mike Busselle. **99** Anne Hickmott.

Additional commissioned photography by Gugliemo Galvin, Toby
Glanville, John Goldblatt, John Heseltine, John Miller, Mike Newton,
Richard Platt. Tim Stephens, George Taylor.

Acknowledgment Chemical Formula on p. 97 reproduced by courtesy
of *The British Journal of Photography Annual.*

Artists David Ashby, Gordon Cramp, Tony Graham, Edwina Keene,
David Mallott, Coral Mula

Retouching Bryon Harvey

Kodak Panatomic-X, Tri-X and Technidol are trademarks

Time-Life Books Inc. offers a wide range of fine recordings, including a
Big Bands series. For subscription information, call 1-800-621-7026, or
write TIME-LIFE MUSIC, Time & Life Building, Chicago, Illinois 60611.